G000093713

# SECRET
# CORK

## Kieran McCarthy

AMBERLEY

# Acknowledgments

I would like to thank Amberley Publishing for their advice, experience and vision to publish this book; I would also like to acknowledge the contribution and support of Mairéad Mooney, Seán Kelly and the expertise of the Libraries, Museum and Archive staff of Cork City Council.

*Dedicated to Mairéad and walks across the fair city*

First published 2017

Amberley Publishing
The Hill, Stroud
Gloucestershire, GL5 4EP

www.amberley-books.com

Copyright © Kieran McCarthy, 2017

The right of Kieran McCarthy to be identified as the Author of this work has been asserted in accordance with the Copyrights, Designs and Patents Act 1988.

ISBN  978 1 4456 6714 0 (print)
ISBN  978 1 4456 6715 7 (ebook)

British Library Cataloguing in Publication Data.
A catalogue record for this book is available from the British Library.

Origination by Amberley Publishing.
Printed in Great Britain.

# Contents

# Introduction – Hidden Treasures

It is over twenty years since I gave my first walking tour across the flat of Cork city and over eighteen since I began writing my weekly column series 'Our City, Our Town' in the *Cork Independent*. Both have given me much pleasure and I have really enjoyed researching and promoting Cork's story. It is a great story to research and to tell. One cannot but be pulled into the multitudes of narratives that have framed Ireland's southern capital.

For all the tours and for all the columns and themes though, I still seek to figure out what makes the character of Cork tick. I still read between the lines of historic documents and archives. I get excited by a nugget of information that completes a historical puzzle I might have started years ago. I have sat in the library pouring over a book or old newspaper on many occasions trying to figure out where a piece of information sits in my researches. I still look up at the architectural fabric of the city to seek new discoveries, hidden treasures and new secrets. I encourage people on my tours to look up and around and they always see something that I have not. I am still no wiser in teasing out all of Cork's biggest secrets. But I would like to pitch that its biggest secret is itself, a charming urban landscape, whose greatest secrets have not been told and fully explored.

We all become blind to our home place and its stories. We walk streets, which become routine spaces – spaces we take for granted – but all have been crafted, assembled and storified by past residents. It is only when we stand still and look around that we can hear the voices of the past and its secrets being told.

I have articulated over the years that there is a power of place – that the concept of place matters. Cork is a place of tradition, continuity, change and legacy. It is a place of direction and experiment by people, of ambition and determination, experiences and learning, of ingenuity and innovation and a place of nostalgia and memory. Beyond the physical surfaces of a city such as Cork, there is a soulful and evocative character etched across the flat of it, the estuary of the River Lee and surrounding valley sides. Place matters in Cork. Within this topographical frame is a heritage – physical and spiritual to a degree – that needs to be minded, cherished and nourished.

Cork's place and story has been carved over many centuries and all those legacies can be found in its narrow streets and laneways and in its built environment. The legacy echoes from being an old ancient port city where Scandinavian Vikings plied the waters 1,000 years ago – their timber boats beaching on a series of marshy islands, and the wood from the same boats forming the first foundations of houses and defences. We will never know and will always speculate upon their raison d'être to construct such a settlement upon a wetland. Themes of survival, living on the edge, innovation, branding

and internationalisation are depicted in much of Cork's built heritage and are among my favourite topics to research.

This publication is a companion volume to *Cork City History Tour* (2016) and contains sites that I have not had a chance to research and write about in any great detail over the years. *Secret Cork* takes the viewer on a walking trail of over fifty sites. It starts in the floodplains of the Lee Fields looking at green fields that once hosted an industrial and agricultural fair, a series of Grand Prix's, and open-air baths. It then rambles to hidden holy wells, the city's sculpture park through the lens of Cork's revolutionary period, onwards to hidden graveyards, dusty library corridors, gazing under old canal culverts, across historic bridges to railway tunnels. *Secret Cork* is all about showcasing these sites and revealing the city's lesser-known past and atmospheric urban character.

Enjoy!
Kieran McCarthy

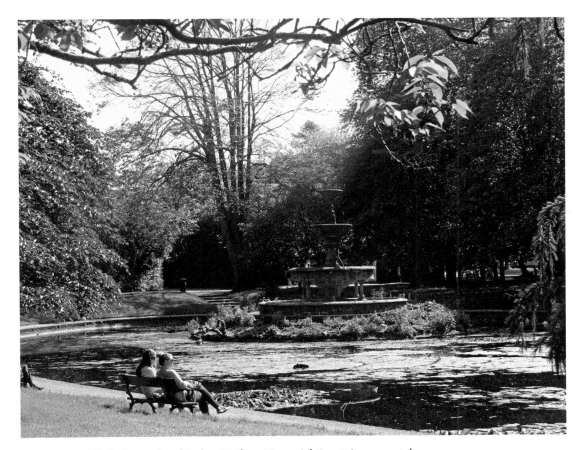

Fitzgerald's Park, pond and Father Mathew Memorial Fountain, present day.

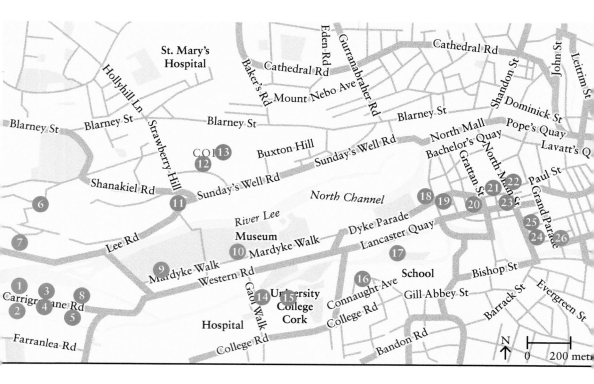

**Secret Cork Tour Key**

1 The Lee Fields and River Lee
2 Record Setting on the Straight Road
3 Grand Prixs on the Straight Road
4 Irish National and Agricultural Fair
5 Cork County Hall
6 Cork Lunatic Asylum
7 Old Cork Waterworks
8 Lee Baths
9 The Mardyke Walk
10 Fitzgerald's Park
11 Sunday's Well
12 Cork City Goal
13 Good Shepherd Convent

14 Cork County Goal
15 Queen Victoria Monument
16 Boer War Memorial
17 River Lee Hotel
18 Lee Maltings
19 Volunteer Hall, Sheares Street
20 Fenn's Quay
21 St Francis Church
22 North Main Street, Paradise Place
23 St Augustine's Church
24 The Children's Library
25 Masonic Hall
26 Yellow Horse, Grand Parade

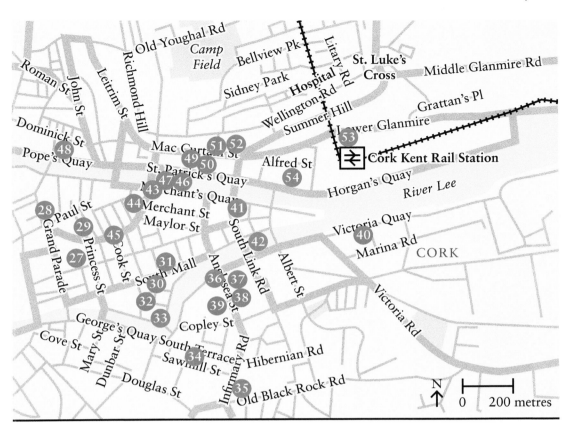

# 1. Western Perspectives

## The Artery of the City, the Lee Fields & River Lee

The River Lee defines Cork and its development. It is a core artery of the city and its western region. Many have crossed over the river's bridges and have appreciated its tranquil, hypnotic flow. It reflects vitality, engages the senses and presents an air of mystery and secrecy. The River Lee is an accessible amenity that all can appreciate. At the Lee Fields, the notion of a divide between town and country are merged. Places such as its source in the Shehy Mountains or the pilgrim site of St Finbarre's Gougane Barra and its mouth at Cork Harbour are connected. The geography of the river valley from west to east is fractured and diverse. It is a beautiful landscape, a landscape transformed through the centuries by people. The diverse archaeological monuments from Stone Age tombs to the solitary Norman or Irish castle to the nineteenth-century churches reflect the use of the River Lee Valley and its scenery and resources by its residents for the nourishment of the soul, living and surviving. The townland names of the ordnance survey reflect a human story, especially the impact of human history on the natural landscape. It is an impact that spans thousands of years.

The origin of the name Lee is sketchy and legend reputedly attributes the name to an ethnic group known as the Milesians from Spain, who reputedly arrived in Ireland several thousand years before the time of St FinBarre. Legend has it that the Milesians acquired land in southern Munster, which they named 'Corca Luighe' or 'Cork of the Lee' from Luighe, the son of Ith who attained the land after the Milesian advent to Ireland. The River Lee – An Laoi – over the centuries has had many variations of spelling. In early Christian texts, such as the Book of Lismore, it is described as Luae. It has also been written as Lua, Lai, Laoi and the Latin Luvius. An entry in the Annals of the Four Masters in the year AD 1163 names the river Sabhrann. However, many scholars agree on the name Lee as the most common name of the river.

The area drained by the River Lee and its tributaries is around 400 square miles and has a number of tributaries. The principal drainage is from the north from the Derrynasaggart and Boggeragh Mountains, while in the south the watershed is lower and supplies a lesser volume of drainage. The Lee can also be divided up into three well-defined stretches. The first is the highland and foremost rugged section from Gougane Barra to near Macroom. Here are the signs of glaciation with sharp limestone ridges and ancient lakes. The second section is the immediate area affected by the Lee Hydro Electric Scheme, encompassing Carrigadroid and Inniscarra Reservoirs to where the river meets the tidal estuary at Cork city's Lee Fields. The gates of the two dams were closed in 1956 by the Electricity Supply Board (ESB) and flooded out 3,500 acres of land. The third section is the complex tidal estuary of Cork Harbour, which opens up from the city under historic bridges through islands such as Great Island and Spike Island through to Roches Point Lighthouse. Within each of the three sections there are many local histories, many of which are written down; some of these are remembered within communities and some are forgotten. The Lee for me is Cork's biggest secret and asset.

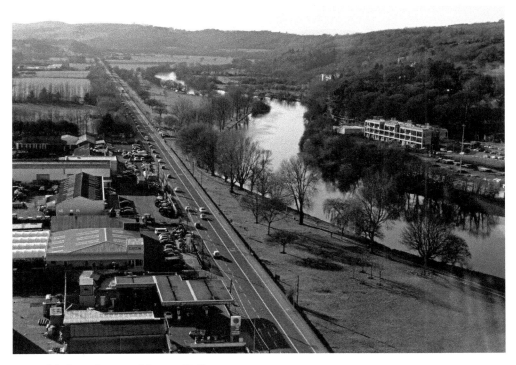

Lee Fields from the top of County Hall.

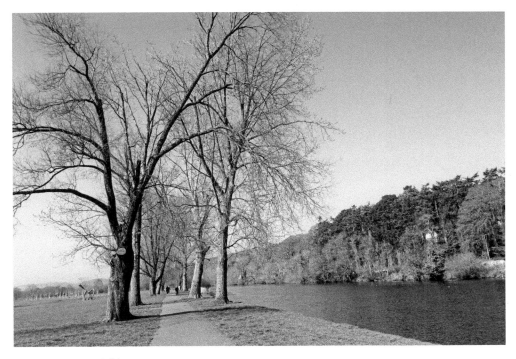

River Lee at Lee Fields.

## Among the Nations of the Earth: Record Setting on the Straight Road

The history of Cork roads is diverse. Some were created as routeways for agricultural produce such as butter, some as famine relief projects and some were inspired as national symbols of the city's and country's place in the world. Since its creation in the early nineteenth century, Carrigrohane Straight Road has always played a key part in the life of the city as a western routeway. In the early Irish Free State, tarmac was introduced on Cork roads and the Straight Road in 1927 became a 2.5-mile concrete road, which inspired the breaking of professional speed records of motorcycles. The first major attempt to set a record was at a motorcycle speed meeting in 1929 at which speeds of a 100 miles per hour were attained. The first fastest motorcycle record was set unofficially by Glenn Curtiss in 1903. The first officially sanctioned Fédération Internationale de Motocyclisme record was not set until 1920. In mid-1930, Joseph Wright of Britain lost the motorcycle speed record to Jacob Ernst Henne (BMW) of Germany. Later that year, plans were made to retake the record. The 1930 Motorcycle Exhibition at Olympia, London, was coming up in the second week of November 1930 and it was generally felt it would be good for business if a British machine could regain the record.

A few days before the London Motorcycle Exhibition in early November 1930, the Cork and District Motor Club directed the organising bodies of the new record attempt by British interests to the Carrigrohane Straight Road. The road's fine surface brought Joseph S. Wright, one of Great Britain's foremost motorcycle racers, to Cork to attempt a new record. French officials arrived in Cork with special electric timing apparatus. Lieutenant-Colonel Crerar was director of the test. The first attempt was on 5 November 1930 but was postponed owing to continuous rain and greasy conditions on the road. The trial took place the following day.

Joseph Wright rode a 1,000 cc QEC Temple JAP-engine machine and regained the record by clocking just over 150 mph. Appearing in a British Pathé movie, his clothing was strapped down to cut back on wind resistance. He even had tape put around his throat. He wore a streamlined motorcycle helmet. The bike was towed behind a car to

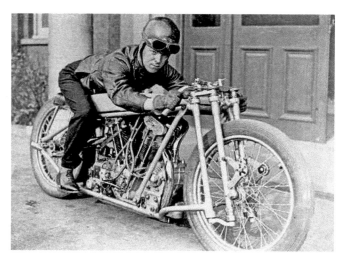

Joseph S. Wright, 1933, in Lancastershire.

get up to starting speed. The bike was built by Claude Temple who had himself already broken the speed record for motorcycles in around 1927. Lord Mayor Frank J. Daly hosted representatives of J. A. Prestwich & Co. Ltd and Joseph Wright at a dinner on the night of the record feat. In his address, he noted that the government of the Free State was most anxious to foster and cater for anything that would 'help the Saorstát to keep its place amongst the nations of the earth'.

## Intense Thrills, Grand Prixs on the Straight Road

The years 1936–38 will be remembered as those that coincided with a sense of the international stitched into the Carrigrohane Straight Road. In the years 1929–31 Phoenix Park, Dublin, was the key venue for the Irish Grand Prix in motorcar racing and was very well supported. Similarly, thousands of people came out on 5 August 1935 to see the first Grand Prix race in Limerick. Inspired by the Limerick races, the people of Cork were spurred to host a similar event in 1936 and subsequently in 1937 and 1938. The viability of organising a motor race in Cork was initially mooted by the lord mayor, Alderman Seán French. A committee was set up under the chairmanship of R. H. Tilson. They sought to further develop the populace interest in automobile sport south of the River Shannon and to investigate the benefit it would bring to the city of Cork and the surrounding area. The Royal Irish Automobile Association (IMRC) were written to. Formed in 1901, they are now one of the oldest motor clubs in the world. They had asked them to be promoters of the planned Cork race. The Government Roads Department and Cork County Council invested in bringing the chosen circuit in the Carrigrohane Straight Road area up to the required standard for the running of such an event. The Cork business community also invested in getting the project up and running.

Being the first time the venture was run in Cork, the race was not granted international status. An entry of twenty-seven was received. The most famous of the drivers was Austin Dobson of Surrey, who piloted the Alfa-Romeo in which the Italian ace Nuvolari won the German Gran Prix in July 1935. This car was reputed to be the fastest ever seen in Britain and Ireland, being capable of speeds up to 180 miles per hour, and in it Dobson was hoping to set a new record. He already held the Phoenix Park record with 99.6 mph. The majority of the English drivers who came for the Cork race arrived from Fishguard on the MV *Innisfallen*.

On Saturday 16 May 1936, the race day, the entire 6.25 miles of the course was crowded on both sides while all the vantage points held crowds six or seven deep. The distance of the track was 201 miles, or thirty-three laps of the circuit. The starting time was 3.30 p.m. and the estimated time of the race was two hours and twenty minutes. This is shown in the British Pathé short film of the event. In this there are various shots of cars starting the race in groups, multiple shots of the race and the crowds of people watching from walls of houses and front gardens along the race route. The *Irish Press*, in their press coverage (18 May 1936, p. 12), noted that the course did not prove as fast as anticipated. Speeds of up to 130 mph were attained in the 2-mile Carrigrohane Straight Road but the back stretch, with its curving and undulating nature, was a severe test for cars and drivers. There was the Victoria Cross semi-hairpin, the Poulavone hairpin, the wide right-angled Dennehy's Cross and the wide 'S' at the Gravel Pit bend, where the steep descent to a left-hand turn

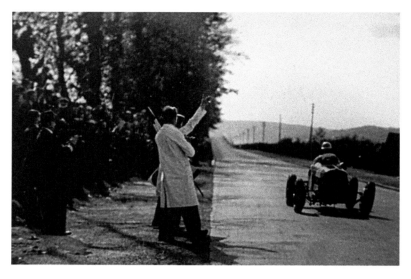

Motorcar racing on the Carrigrohane Straight, 14 May 1936.

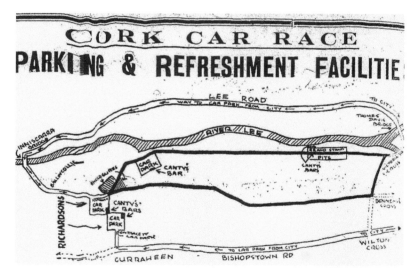

Rough sketch map of the 1936 Motor Car Race.

called for, as the *Irish Press* noted, 'extreme caution or dare devilry'. Reginald Ellis Tongue of Manchester won the race in an English Racing Automobile, or ERA, at an average speed of 85.53 mph, in two hours, twelve minutes and twenty-two seconds. Such was the success of the 1936 race that two further Grand Prix's took place on the Straight Road and environs in 1937 and 1938.

## A National Venture: Irish National and Agricultural Fair

The ambitious Irish Industrial and Agricultural Fair was held in Cork in 1932, attempting to showcase Cork and Irish products in the early Irish Free State. Located in the southern section of the Lee Fields, south of the Straight Road, it is a lesser-known fair in the history

of the exhibitions in Cork. It was the fourth attempt (1852, 1883, 1901/02 and 1932) within eighty years to showcase Cork and its assets on a national and international stage.

Over 80 acres of land just off the Carrigrohane Straight were purchased from Mr T. Corcoran, vice-chairman of the Cork County Council, for this enormous fair. The architect responsible for the layout and design of an array of buildings was Mr Bartholomew O'Flynn, No. 60 South Mall, Cork. The key buildings at the 1932 fair were listed as the 'Industrial Hall', 'Palace of Industries', 'Hall of Commerce', 'Hall of Agriculture', 'Concert and Lecture Hall', 'Art Gallery', 'Tea Rooms' and two large bars for which special licensing legislation was passed. Messrs O'Shea Ltd, No. 41 South Mall, were the successful contractors for the building of the industrial halls, restaurants and car parks. The Hall of Agriculture, main entrance and offices were constructed by Mr E. Barrett, Knockeen, Douglas Road, Cork, while the bars and lavatories were built by Messrs Coughlan Bros, Sawmill Street. Mr Barrett was also responsible for the construction of an enquiry bureau on Cork's St Patrick's Street as well as the drainage system of the fair and a number of stalls and kiosks. Greenhouses and other structures in the agricultural and horticultural sections were erected by Messrs Eustace & Co Ltd, No. 43 Leitrim Street. Messrs Barry & Sons Ltd of Water Street provided the timber for the buildings.

Over 50,000 people visited in the first two weeks of the six-month run. Conscious of the fact that the fair was on the edge of the city, a new wide footpath was built along the Straight Road. The motorcar visitor could park in an organised car park, which accommodated upwards of 3,000 cars under the supervision of the fair authorities. Special exhibition buses, operated by the Irish Omnibus Co., ran from the city centre to

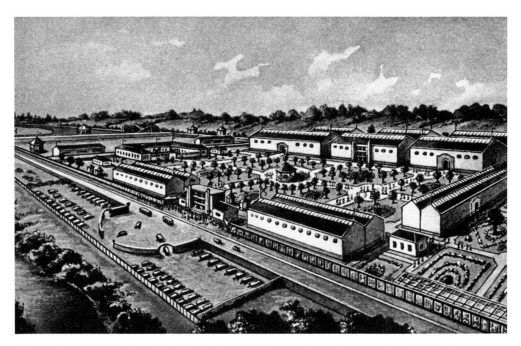

Illustration of Irish Industrial and Agricultural Fair grounds, Carrigrohane Straight Road, 1932.

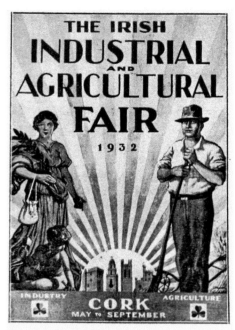

Choose Cork for your 1932 Holiday.   Fair advertisement, 1932.

and from the grounds. Special trains running from the Western Road terminus of the Muskerry Light Railway ran in the evenings to the site and back again.

In the years following the fair, a city dump or landfill was located on the site. This landfill remained in place for a number of decades before the Kinsale Road landfill came into being. That perhaps also added to the memory of the Irish Industrial and Agricultural Fair disappearing out of Cork's public history. The site in recent years has become playing pitches.

## A Skyscraper to Catch the Eye: Cork County Hall

Cork County Hall for many years had the title of the tallest building in Ireland, to be surpassed by the Elysian Tower on Eglinton Street, just east of Cork city centre. Since 1899, Cork County Council met at Cork City Courthouse and various departments of the council were scattered throughout the county. A site was purchased prior to the Second World War, but with the rapid post-war expansion of the local government services, it was decided that the site, located in the city centre, was entirely inadequate. In 1953, the idea of a central headquarters for the council's officers was first mooted by Mr Joseph F. Wrenne, first county manager. At the time, the times and costs were not considered. Mr Owen Callanan succeeded Mr Wrenne and he attained the council's approval in principle to one big roof for all in 1954.

The original proposed building was to be ten storeys, 116 feet tall, 187 feet long and 42 feet high. Its long frontage was to face the Carrigrohane Road at a cost of £137,000. The final plans were different to what was originally proposed. The County Hall as finally

designed cost £500,000, was seventeen storeys high, 211 feet tall, 131 feet long and 46 feet wide, and the main entrance faces the city. Cork County Council acquired the site from John A. Wood. Previously, the greater part of the land was the headquarter grounds of the Munster Football Association. In 1964, the tender for the sum of £479,508 was accepted from Cork's largest firm of building contractors, Messrs P. J. Hegarty & Sons, Leitrim Street, for the construction of the seventeen-storey skyscraper, which was designed by Cork County Council Architect Patrick McSweeney.

A design feature also made it possible to build higher than ever before without the necessity for scaffolding, which would have cost around £20,000. The cost cutter was to extend the floors beyond the outer walls so that each successful floor became the work platform for the laying of the next floor on its supporting twenty-eight columns and beams. The beams were 14 inches thick and the floors were comprised of 6 inches of reinforced concrete. The building rose at the rate of one floor every three weeks until it reached the sixteenth floor. Instead of finishing off the upper storeys, a decision was made, arising out of the expectation of the advent of the worst of winter weather, to consolidate the lower floors, installing curtain walling, glazing internal partitioned walls and giving the building a chance to dry out.

At the base of County Hall are two bronze figures. Originally commissioned from Oisín O'Kelly by the Transport Union and designed to stand at the base of Liberty Hall in Dublin, the union's skyscraper headquarters, the figures could not be erected because Dublin Corporation refused planning permission. Through the generosity of the Irish Transport and General Workers' Union, the figures were acquired on loan by the Cork

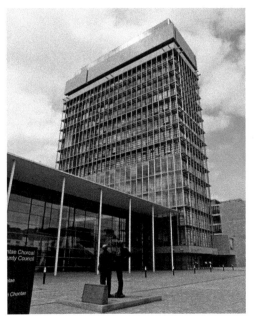 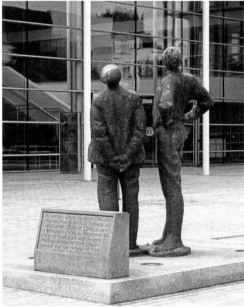

*Left*: Cork County Hall.

*Right*: Statues by Óisín Kelly, Cork County Hall.

Sculpture Park Committee. In 1969, they came to Cork through the good offices of the sculpture committee and were put on exhibition in Fitzgerald's Park. When the time came to pack them up and send them back to Dublin, the committee felt that it was a pity to see such beautiful artistic work going away for possible storage. It was at this stage that the Cork branch of the Transport Union stepped in and, through their influence, the figures were retained in Cork on loan for exhibition at County Hall. In February 1971 Mr Pat MacSweeney, the county architect, had them placed in a most appropriate position in front of the 211-feet-high hall.

## Ireland's Longest Building: Cork Lunatic Asylum

Etched into the northern skyline overlooking the Lee Fields is Ireland's longest and one of its most atmospheric buildings. The old Cork Lunatic Asylum was built in Victorian times. The first asylum for what contemporary Cork society deemed 'insane' in Cork was founded under the Irish Gaol Act of 1787/8. The Cork Asylum was the second of its kind to be established in Ireland and was to be part of the South Infirmary on Blackrock Road. The Cork Asylum in the late 1840s lacked finance and space to develop a proper institution. A Committee of the Grand Jury of Cork County (leading landlords and magistrates) examined the existing asylum and began a verbal campaign for its replacement. In 1845, a Westminster act was enacted to create a district asylum in Cork for the city and county of Cork.

In April 1846, a Board of Governors of the asylum at the South Infirmary purchased and commenced work at a new site in Shanakiel. The board set up a competition of tender for an architectural design. Mr William Atkins was appointed, with Mr Alex Deane as the builder. Work commenced in mid-1848.

The asylum was located on a commanding location on a steep hill overlooking the River Lee. The building was three floors high and was divided into four distinct blocks. Three blocks were located at the front and were designed to contain the apartments for patients, along with the residences for the physicians, matron and other officials of the asylum. The building materials were reddish sandstone rubble, obtained near the site, and grey limestone quarried from sites on the opposite site of the River Lee. Internal fittings such as fireplaces were said to be of marble supplied also from the south side of the city. The fourth building block was located at the rear of the central block, and comprised the kitchen, laundry, workshops, bakehouse, boiler house and other rooms of an office nature. Heating was steam generated in a furnace house.

The new asylum was named Eglinton Lunatic Asylum after the Earl of Eglington, and was opened in 1852. The principal types of people admitted, which made up the highest number, comprised housewives, labouring classes, servants and unemployed. Forty-two forms of lunacy were identified from causes such as mental anxiety, grief, epilepsy, death, emigration to 'religious insanity', nervous depression, want of employment and desertion of husband or wife.

Plans for an extension to Eglington Asylum were put together in the 1870s. The aim was to accommodate over 1,300 patients. The three blocks were connected into a single building. In 1895, the Cork Asylum was described as one of the most modern asylums in Western Europe. The staff was made up of seventy-two men and

fifty-six women. Lectures were given to staff by lecturers of mental illness at Queen's University College Cork, now University College Cork. A Church of Ireland chapel was completed in November 1885 with William Hill as architect. In 1898 a Roman Catholic church was designed by Hill. In 1899 a new committee of management for the asylum was established under the newly formed Cork County Council. In 1926 the asylum became known as Cork District Mental Hospital. In 1952 the hospital's name was changed to Our Lady's Psychiatric Hospital. The complex closed in the late 1980s. In recent years, parts of the main grey building have now been redeveloped into apartment units.

## Pulses of Power: Old Cork Waterworks

The pulse and power of the river was once used in the old Cork City Waterworks. The buildings that stand at the waterworks site today date from the 1800s and 1900s, but water has been supplied to the city of Cork from the site since the 1760s. A foundation stone today commemorates the building of the first pump house, which was itself constructed on the Lee Road in the late eighteenth century. It was in 1768 that a Nicholas Fitton was elected to carry out the construction work needed for a new water supply plan. The waterwheel and pump sent the river water unfiltered to an open reservoir called the City Basin, which was located on an elevated level above the Lee Road. This water was then pumped from here to the city centre through wooden pipes.

Between the years 1856 and 1857, the Corporation obtained a sanction from the parliamentary treasury to acquire a loan of £20,000 to upgrade the Lee Road waterworks.

Cork coat of arms on the chimney of the old waterworks, present day.

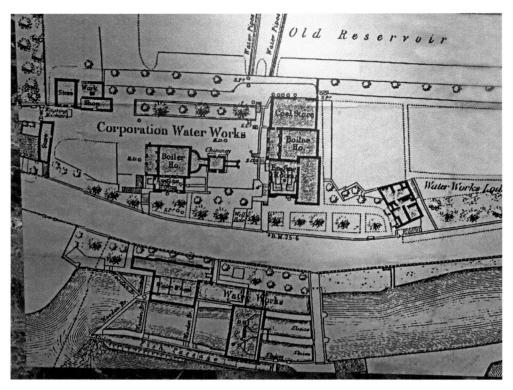

Map of Cork Corporation Waterworks on Lee Road, *c.* 1910.

In February 1857 John Benson's plan for a new waterworks was given to several eminent engineers in London for consultation. Much of it was based on Londoner Thomas Wickstead's 1841 survey and plan for the provision of water to the Cork public in association with the Corporation of Cork. By May 1857 tenders were issued and cast-iron mains were chosen to replace the wooden pipes. They were initially shipped to Cork in 1857 and during the ensuing two years the pipes were laid down. By February 1859 the pipes from the new waterworks to the military barracks on the old Youghal Road were in place. It was here that a new reservoir was to be constructed. The reservoir itself was to cover 1 acre and was 5 metres deep with a capacity of 4 million gallons.

During 2004 and 2005, the old waterworks building went through a renovation programme. Officially opened in October 2005, the site of the old waterworks is now known as the Lifetime Lab, a Cork City Council initiative funded by EFTA or the European Free Trade Association. The former engine rooms are now used to house an exhibition on different environmental topics including energy, waste and water. The former coal store houses the conference theatre and meeting room and the former boiler house is now the main reception area for Lifetime Lab. The engines and boilers still remain in the buildings today. A new visitor experience is now available at Lifetime Lab. The new addition offers a multisensory, 360-degree experience charting the development of the former Victorian waterworks in tandem with the development of Cork city and the story of the River Lee.

## Diving into History: Lee Baths

Photographs, a square hut of concrete in the Lee Fields and memories are all that remainsof the infamous Lee Baths. The summer of 1934 coincided with the opening of Cork's new municipal and open-air unheated swimming pool on the Lee Fields. Billed as one of the largest of its type in Ireland, it was officially opened on Wednesday afternoon 20 June 1934 by Mr Hugo V. Flinn TD, parliamentary secretary to the Minister for Finance. There was a growing interest internationally in swimming and the popularity of swimming pools was spreading. Oliver Merrington, in his work on the history of open-air swimming pools, records that over thirty-seven such pools opened in the UK in the 1930s. In Cork the Eglington Street Baths (which were opened in 1901) could not accommodate the growing numbers of swimming enthusiasts.

City Manager Philip Monahan, with City Engineer Stephen Farrington, set out to create an enterprise of considerable magnitude, which would have in it a large labour content for even the unskilled labourer, plus create a municipal project that would have social and economic value. In the wider context, Monahan was probably well aware of the growing interest internationally in swimming and how the popularity of swimming pools was spreading.

The inaugural gala at the Lee Baths took place after the official opening on 20 June 1934. Witnessing the events was the Lord Mayor Sean French, Hugh V. Flinn TD and other guests. Competitors compared the new site favourably with the Eglinton Street baths and spectators commented on their spacious accommodation. The programme comprised schoolboy, junior and senior squadron races, a polo match and several novelty events; the schoolboys squadron race was won by Christian Brothers College

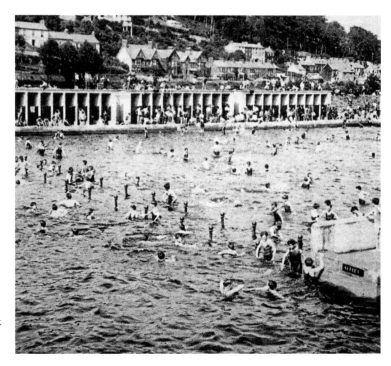

Photograph from Cork Corporation diary, 1934, of the Lee Baths.

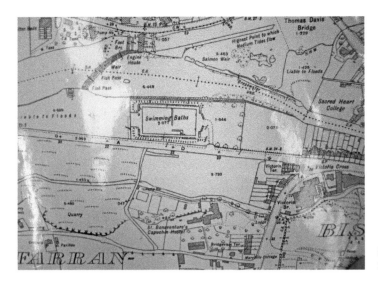

Section of 1948 OS map of Lee Fields.

and second went to Presentation Brothers College. The junior squadron race was won by the Republican Swimming Club, second went to Sunday's Well and third place to Dolphin. The senior squadron race was won by Sunday's Well, second went to Dolphin and third to Highfield. A lifesaving exhibition was given by R. Bogan and P. Renouf. In the senior polo challenge match, Sunday's Well were defeated by Dolphin by five goals to one. In the swimming, a number of strokes were demonstrated including breaststroke, lifesaving backstroke, overarm sidestroke, trudgeon stroke, trudgeon crawl, back crawl and dual rhythm crawl.

In the early years, women were not allowed to swim in the Lee Baths. The *Cork Examiner*'s record of the opening day highlights a letter of protest against the exclusion of ladies at the baths; seventy signatures were attached to it, the majority of which were women, others including that of a TD. They claimed that the Corporation was abusing its authority by prohibiting a large section of the population from bathing at the Lee Baths. Their letter gave the example of equality at the open-air pools at Blackrock and Dalkey in Dublin Dun Laoghaire, Bangor, Portrush, Armagh, Warrenspoint and Newcastle. They asked for restrictions to be lifted at the Eglinton Street baths and for the entire use of those baths during the summer months for women. Their requests were only met years later. The site of the Lee Baths is now the Kingsley Hotel.

## Heavenly Musings: the Mardyke Walk

One of the most innovative recreational features of early eighteenth-century Cork was the Mardyke Walk and House, both built upon a swamp to the west of the city and both instrumental in opening up interest in this area. Between 1719 and 1730, the area around the Mardyke was known generally as the West Marshes. However, in 1719 a large section of land was bought by the town clerk, Edward Webber, who decided to build a raised walkway across the marshes as the step to reclaiming them. Edward Webber himself was a descendant of a Dutch merchant. Consequently, he named his raised walkway after a

promenade in Amsterdam called the 'Meer-Dyke', which means 'an embankment to protect the land from the sea'.

While constructing the walk, he also built a teahouse of red bricks, which was the first of its kind in Cork. Fruit gardens and pathways of gravel were put down along with stone seats for the convenience of the public. The publicity of Webber's teahouse grew and it soon became a place that people of high social status met. After the death of Edward in 1735, his teahouse and gardens continued to prosper for over two centuries but eventually closed in the mid-1940s.

In the late eighteenth century, the rights of pedestrians were violated by horsemen, carriages and drivers conducting their cattle to the neighbouring fields. In 1807 John Day, mayor, had a triple gateway, which became known as 'Hell, Heaven and Purgatory' erected at the city end of the walk near the present entrance to Presentation Brothers Sports Grounds, and this effectively sealed the walk to wheeled traffic. The scheme is said to have been further enhanced through the landscaping by B. Wrixon, who laid down a gravel path admitting ten people abreast and also provided it with seats and alcoves.

Between 1795 and 1850, the gardens and teahouse were used as a summer residence for the mayor of Cork. At one stage people were employed to build an elegant pond and to take care of his grounds. In the early 1830s people again started to use the walk. The renewed interest by the public led the Corporation to make the promenade more attractive by erecting a slate-covered bandstand. The walk was walled in with parapet walls, by the Wide Street Commissioners and the Corporation of Cork.

Wilkie's Cork City Directory 1872 was similar in today's context to a tourism brochure on the city. Among the public walks, the Mardyke claimed Wilke's first attention. He described it as a very splendid avenue of around an English mile in length, lined with a double row of lofty elm trees, 'whose wide-spreading branches, when in foliage, covered the entire walk and thus creating a most agreeable shade to the pedestrian'. The walk over

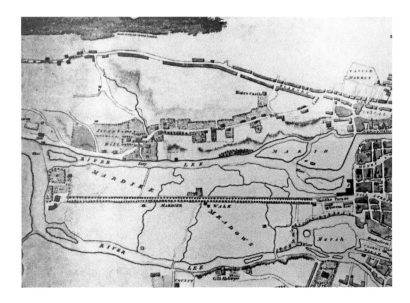

Map of
Mardyke, 1801.

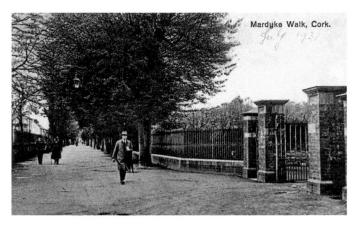

Mardyke Walk, *c.* 1900.

many decades suffered from the construction of housing in the late nineteenth century and the mid-twentieth century and increases in traffic. It is only in recent years through a further revamp of Fitzgerald's Park and the creation of the Mardyke Arena by UCC that traffic calming measures have been installed; only echoes of the heyday of the Mardyke remain.

## A Municipal Sculpture Park, Fitzgerald's Park
Long before the end of the Cork International Exhibition at the Mardyke in October 1903, the organisers wished to give the grounds to the people of Cork as a place of recreation. A decision was taken to name the new public space after the organiser of the Exhibition Edward Fitzgerald. A general Park Committee was agreed upon and established. This was to be a group who would promote and provide funding for band recitals, 'water carnivals' and the upkeep of the park. The park would always be free to the public but the committee reserved the right to charge a 6*d* admission fee during a certain time in the year. This was to defray the cost of landscaping the park, a cost of £400 a year.

Two years passed (1905) and the Park Committee were deemed ineffective by their peers. In March 1906 it was agreed to vest the park and the Shrubberies House in the Corporation with the provision that the Corporation would levy a rate of a half penny in the pound through municipal taxation for the annual upkeep and maintenance. A further provision provided that the Shrubberies House be turned into a municipal museum. After the arson attack and subsequent destruction of Cork City Hall in 1920, the Shrubberies House was used as municipal offices for Cork Corporation during the restructuring of City Hall, which had been burned down by the British Auxilliaries in December 1920. In the 1940s, during the Second World War, it was used as the Air Raid Precautions Headquarters for the city. On 4 April 1945 it reopened as Cork Municipal Museum and was restructured through the decades into a modern-day museum.

Around the mid-1960s, a Cork Sculpture Park Committee was established to create one in Fitzgerald's Park. Music Professor Aloys Fleischman was the committee's chairman. Seamus Murphy's bronze bust of Michael Collins was one of the first of series of sculptures by the artist to be unveiled in the park's landscape on 15 June 1966. In November 1977

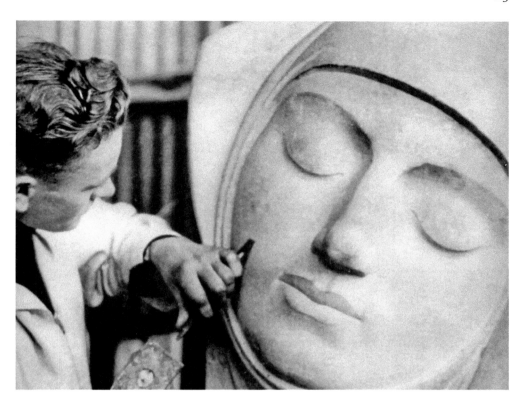

*Above*: Seamus Murphy carving *Dreamline*, now on display in Fitzgerald's Park.

*Right*: *Dreamline*, Fitzgerald's Park, present day.

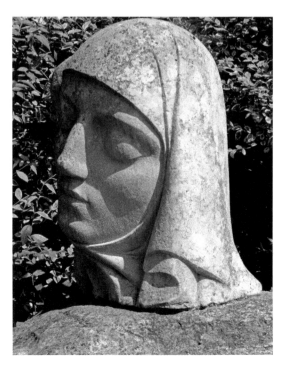

Seamus Murphy's *Dreamline* was an over-life-size study of the head of the Madonna, carved in Portland stone and completed by Seamus Murphy in 1932, when he was twenty-five years of age. It was first exhibited in 1934 in Cork. Later it was shown, among other places, at the Royal Hibernian Academy in Dublin and later in places such as Fitzgerald's Park. The work of art of other artists such as Marshall C .Hutson and Joseph Higgins can also be viewed in the park. In 2016 a Seamus Murphy bronze cast of *Eamonn DeValera* was donated to Cork City Council and erected on a pedestal in the park. The installation of the sculptures in the park through time also inspired the situating of sculptures in other parts of the city.

## A Blessed Landmark: Sunday's Well
Sunday's Well was a famous landmark through Cork's past and the adjoining district took its name from the well. In 1644, the French traveller M. de La Boullaye Le Gouz visited Ireland. In the account of his journey he writes, 'A mile from Korq [Cork] is a well called by the English, Sunday Spring, or the fountain of Sunday, which the Irish believe is blessed and cures many ills. I found the water of it extremely cold'. Charles Smith in his second volume of his History of Cork in 1750 mentions 'a pretty hamlet called Sunday's Well, lying on a rising ground ... here is a cool refreshing water, which gives name to the place, but it is hard, and does not lather with soap'. Antiquarian Thomas Crofton Croker described the well in his 1824 published work: 'Sunday's Well is at the side of the high road, and is surrounded by a rude, stone building, on the wall of which the letters HIS mark its ancient reputation for sanctity. It is shadowed over by some fine own ash trees, which render it as a picturesque object.' Writing later still John Windele in 1839 says of the well: 'Early in the mornings of the summer Sundays may be seen the hooded devotees with beads in hand, performing their turrish or penance, besides this little temple.'

Sunday's Well is no longer visible. At the beginning of 1946, the adjoining roadway was widened and improved; it was necessary to remove the stone building covering the well, and to run the road over the well. However, to mark the site, the stone tablet bearing the inscription 'HIS, Sunday's Well, 1644', which had been on the building, was placed on the wall adjoining the road. Rounds are no longer paid there.

Journeying citywards along the road from Sunday's Well, the road comes to the foot of Wises's Hill, where it meets the North Mall, just before entering the North Mall. Here, high up on the wall of the old North Mall (Wise's) Distillery is a carved white stone, which was a mullion brought probably from the adjoining ruins of the Franciscan Abbey. This carved stone is said to mark the site of another famous well, Tobar an Bhrianach or O'Brien's Well. People used to come from the country around to this well. On one or two occasions, the excise authorities caught some persons bringing out pails of whiskey instead of water. Mr Wise was then obliged to stop this practice and shut up the well and put up a stone to mark where the well was located.

Nearby, the remains of the water well of the North Abbey survives. The well is situated at the foot of a rock face, on the grounds of the Franciscan Well Brewery and is located within a stone-built well house. At one time, the entrance had a wooden panel with the date of 1688 in iron numbers on it. The well is said to be holy in nature but is not dedicated to any particular saint and at one time is reputed to have been used by Corkonians as a cure for sore eyes, consumption and other ailments. Next to the well on its west side there is a second stone-walled

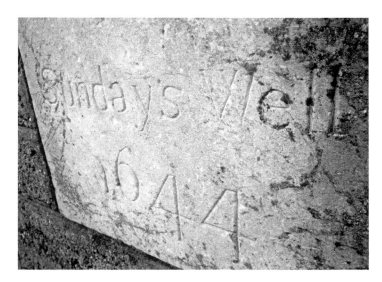

Sunday's Well plaque on
Sunday's Well Road.

Reputed marker of Tobar
an Bhrianach, Wise's Hill.

room, which is partially cut out of the domineering sandstone rock face. The purpose of this room is unknown but the rock face forms the end wall after a number of metres into this space. Legend has it that beyond this end wall is an underground passage leading up into the environs of Gurranabraher. However, the same legend does not relate any stories of its usage.

## Conversations Among Republicans, Cork City Gaol

The exterior sandstone is high and foreboding around Cork City Gaol, which for over two decades has revealed some of its secrets on its popular heritage centre tours. The building of the gaol commenced in 1821, and on 17 August 1824 the first prisoners were locked up in the gaol. Take the tour to discover more about these secrets but perhaps the lesser-known stories are how, against a backdrop of political turmoil in the form of Irish

Free State Civil War, the gaol was used to imprison members of the Irish Republican Army. Eminent examples of internees include many members of Cumann na mBan, especially one patriotic Cork woman, Mary Bowles Countess; Constance Markievicz, famous republican and member of the first Dáil Éireann in 1919; and Frank O'Connor, who went on to become an eminent Irish writer after his release.

The aftermath of the War of Independence in the late 1910s culminated in the 1921 Anglo-Irish Treaty between the proclaimed Irish government and the British government and a subsequent civil war between Irish patriots. Subsequently, many anti-treaty followers were interned in camps and prisons throughout Ireland, including in the gaol in Sunday's Well. In October 1923, a major hunger strike was begun in Mountjoy Gaol in Dublin by prisoners and soon anti-treaty prisoners all over Ireland were involved. In the Cork context, nearly 100 prisoners went on hunger strike and, subsequently, it was decided by Cork Corporation, for the safety of internees, that the unconditional release of the majority of anti-treaty prisoners be passed. The scribbling and drawings from the imprisoned men are preserved on the gaol cell walls and can still be seen today on a guided tour. Indeed, in 1922 the prison is noted as being infested with vermin and a suicide net hung by the iron stairway in front of all second- and third-floor cells.

After the Irish Free State Civil War, the prison closed and any outstanding female prisoners were transferred to other gaols. In 1927, the gaol became the Cork Broadcast Station and in the 1930s any gaol fittings were sold off in auction. Eventually, the radio station closed in 1958. In the late 1950s the building was taken over by the Department of Posts and Telegraphs as a training school. Lectures were even given in the cells on the ground floor. However, in the 1970s and 1980s the gaol was used for this department of government as a store for poles and drums for the locality. This process was eventually phased out in the 1980s. In 1992 plans were drawn up to open the gaol as a heritage centre. Indeed, today much of the building has been remarkably restored, is one of Cork's premier heritage sites and is well worth a visit. In recent times a radio museum has also been added to celebrate the existence of the Cork Broadcast Station of the 1930s.

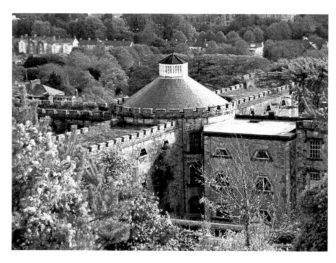

Cork City Gaol Heritage Centre, present day.

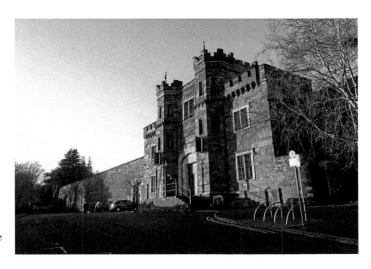

Cork City Gaol Heritage
Centre, present day.

## Haunting Questions, Good Shepherd Convent

Fenced in, haunting and derelict is now the face of old Good Shepherd Convent, Magdalen
Asylum. It first opened to public acclaim on 29 July 1872 and operated as an orphanage
and a Magdalen laundry. The convent was designed by George Coppinger Ashlin for
Dr William Delaney, Bishop of Cork, on a 10-acre site, much of which was donated by
Alderman James Hegarty who also partly funded construction. Works began on the
industrial school wing in 1874. The complex remained in use until winter of 1977 when
year-on-year running costs resulted in the decision to close the facilities. The Cork site
was also one of the forty-one Magdalen Asylums in Ireland of which through time housed
approximately 30,000 women.

At its height at the Cork site, up to 400 women would have been detained in the
convent at any one time. In 1991, when the convent was sold, there were thirty-eight
Magdalene women living there. The Good Shepherd Sisters also operated an orphanage
at the convent, an industrial school named St Finbarr's, which was separated from the
area where the Magdalene women were housed. Some of the Magdalene women who
had conceived outside marriage were kept from and never knew their children, who
were housed within the same complex. The convent's industrial laundry served many
prominent businesses and hotels in the Cork area. Everything happened within the
gates. They also ran their own farm, baked their own bread, and mended their the huge
building, but gradually numbers decreased with the development of foster care, and now
the children live in a separate, purpose-built house on the grounds. A parallel opening
up of the service for girls and women also occurred in the '60s, with many responding to
encouragement to avail employment opportunities.

While there are no publicly available figures for the number of women who passed
through the institution, newspaper records show courts sending women there well into
the 1970s. Grave records show that at least 188 women died while in the care of the Good
Shepherd Sisters in Cork. The Good Shepherd complex was decimated by fire in 2003,
with a number of buildings lost, though the convent and its wings survive in a very

dilapidated state. The story of the asylum, laundry, orphanage and graveyard is subject to ongoing historical critique – in the context of other Magdalene sites and associated activities of work and cases of abuse that took place at a number of sites.

The Cork graveyard includes the grave of the orphan Little Nellie of Holy God, a four-year-old who died of TB in 1908. In the convent, she displayed sanctity and devotion to God remarkable in one so young. When she died at the age of only four from horrific illnesses and disease, moves were made by the church towards canonisation. People came from all over Ireland to pray at her grave in St Joseph's Cemetery and the authorities bowed to a public clamour for the removal of her body to the convent cemetery in Sunday's Well.

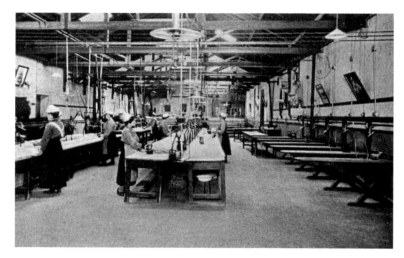

The ironing room, Good Shepherd Convent, *c.* 1900.

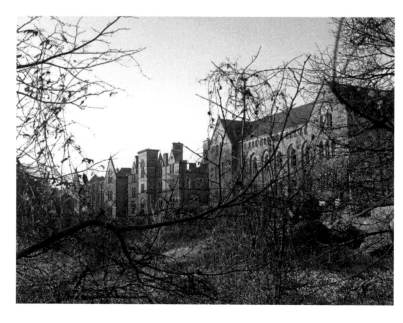

Derelict and ruined Good Shepherd Convent, present day.

When Nellie's body was exhumed in front of witnesses after more than seven months, it was seen to be quite intact. Her hands were flexible and her hair had even grown a few inches. Her white dress was still perfect and the silver medal around her neck, of the Sodality of Our Lady, was as bright as if it was just polished, and the blue ribbon was unfaded. Many were the stories of her intercessory power and her grave became a shrine that drew visitors from worldwide. Pope Pius X asked for, and received, a relic. The queen of Spain later got a relic, but the steps towards possible canonisation ended with the death of Pope Pius X in 1914 and of her sponsor, Bishop O'Callaghan of Cork, two years later. Since then the story of Little Nellie is a key part of the religious history and folklore of the city. There is an ongoing public campaign to open the graveyard to the general public.

## An All-seeing Eye: Cork County Gaol

The only aspect remaining of the Cork County Gaol is its architecturally perfect Doric entrance portico. It was built in 1818 under the direction of the Inspector General of Prisons, Revd Archer. The winner of the contract for building the 'House of Correction' or the chosen architects were the Pain Brothers. This family contributed enormously, in the first half of the nineteenth century, in escalating Cork city's stature as one of the top cities in Europe for architectural style. The House of Correction was built to the north of the earlier prison. It had a central block from which three three-storey buildings stuck out from along with two detached wings. Embedded into the prison's architecture were ideas of surveillance, separation and silence and these were essential to the reform programme for prisoners. The centre block had also the governor's residence on the ground floor, a chapel for Catholics and Protestants on the second floor and an infirmary on the third floor. The radiating buildings provided a panoptical gaze and consisted of seventy-eight cells with washing rooms in each area. Workrooms were located on the ground floor and a detached limestone church could be seen between the earlier gaol and the house.

Prisoners were to be transported to this prison from other counties four times a year, especially after conviction. It is reported that the movement of prisoners from Cork to New South Wales Prison was less dangerous and miserable than the journey from Cork to Dublin. In addition, this new House of Correction was so filled with hardship and misery that young offenders were quick to see the error of their ways. Being locked up with other more hardened criminals made several less experienced culprits repent within days of their conviction. Conditions in this gaol house were much improved. All prisoners were forced to wear set prison clothing and their days were spent in total hardship, either moving the tread wheels or washing down the floors. In 1835, the prison reports state that 978 people were put into the gaol, of which nearly a third were women and just more than a quarter were debtors. The rest had criminal offences. In 1835 also, the Gaol Bridge was built in order to provide access from the newly built Western Road to the County Gaol. Up to then, the only way to get into the grounds of the gaol was via Barrack Street and through College Road, then named Gaol Road. It is a single-arch structure of hewn limestone and was designed by the internationally famous engineer Brunel.

One of the most famous escapes from the prison occurred in 1918 when Donegal-born Donnacha McNeilus, in an elaborate plan involving dozens of men on the outside, was

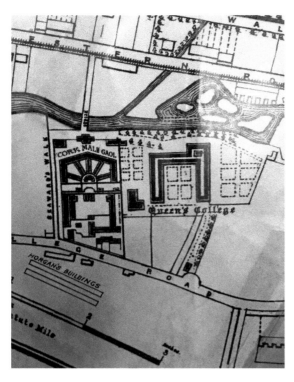

*Left*: Map of Cork County Gaol, 1872.

*Below*: Remaining portico of Cork City Gaol, present day.

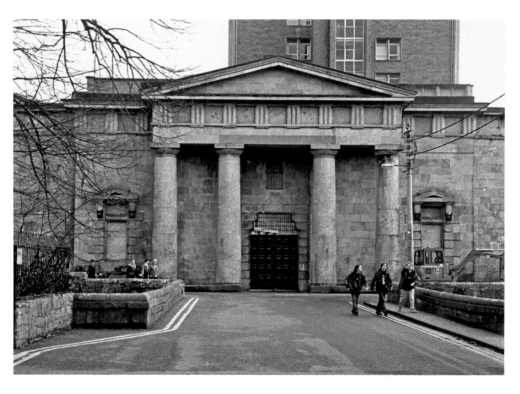

spirited to freedom. Two years later, during a hunger strike by sixty untried Republican prisoners, crowds congregated outside the gates of the gaol each day, many reciting the rosary. In the 1950s the gaol buildings were demolished to make way for the Kane Building – an extension to the UCC campus.

## The Queen Victoria Dilemma

Designed by architects Thomas Deane and Benjamin Woodward, the building of the quadrangle in University College Cork began in early 1847 and was completed within two years. By August 1849 the construction work entered its final stages. However, it was the passing visit of Queen Victoria to the site on 3 August 1849 that captured the interest of many of the public in the new college. Queen Victoria's visit was marked by the unveiling of a statue of the queen, which is located at the eastern end of the roof of the Aula Maxima.

Decades-late political sensitivities forced the monarch off her plinth in the Aula Maxima in the Irish Free State of 1934. Controversy ruled through the Irish Free State years as to why the statue should enjoy a pride of place. In 1934, the solid stone statue of Queen Victoria was taken down from its plinth to be replaced over a decade later by a statue of St Finbarr, executed by the late Seamus Murphy. The statue of the queen was put into storage until 1946 when a permanent resting place was found for it in what was then the 'President's Garden' behind the east wing of the main quadrangle.

During the college's 150th anniversary plans, it was decided to put the statue, the original college charter with its Victorian seal and other memorabilia on display as part of an exhibition. A retired member of UCC's staff, Larry O'Leary, who attended the 1946 burial, as well as two Second World War naval veterans, wrote of the incident: 'Shortly after Her Majesty was placed in the grave one of the naval men produced a bottle of water and just before the first shovelful of earth was cast in the "grave", he stepped forward and sprinkled the contents of the bottle on Victoria.' Then both he and his fellow mariner

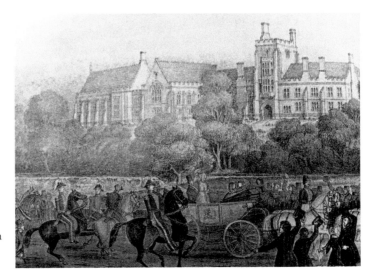

Queen Victoria on her visit to Cork in 1849, overlooking the new Queen's College Cork, with her statue on the West Wing of Aula Maxima.

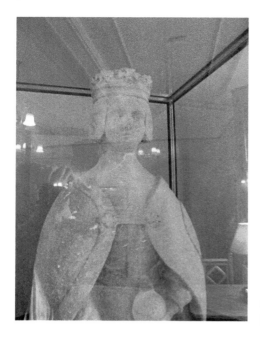

Queen Victoria statue on display at UCC, present day.

sprang smartly to attention and saluted the 'fallen monarch'. The statue now enjoys a position in the staff common room and was viewed by her descendent Elizabeth II on her visit to Ireland in 2011.

## An Uncomfortable Past: Boer War Memorial

Rising from the limestone cliff face of Gillabbey Rock at Connaught Avenue is the elaborate Cork Soldiers' Memorial, a striking Celtic cross with richly cut caps, chiselled bases and striking panels but with now fading and unreadable names. It perpetuates the memory of nineteen officers and 140 non-commissioned officers and men from the county and city of Cork who lost their lives in the South African war in the late nineteenth century. The city's role in the story of the Boer War has not survived in the collective memory frameworks of the city. Hence the cross is in a poor state with a strong emphasis in recent decades on the city's and country's republican heritage, with focus on First World War participants only being spoken about openly in recent years through centenary events of the war. More and more the growing work in pursuing family histories is bringing Cork's international participation in war, empire, controversy and revolution at home and abroad into sharp focus.

It has been estimated that around 50,000 Irishmen fought during the South African war between 1899 and 1902. Many of these were at the forefront of a number of key engagements, serving in Ireland's thirteen infantry battalions and three cavalry regiments. Ireland's imperial connections were further reinforced by the country's impressive civilian contribution to the war effort. At least thirty-three militia battalions were mobilised during the course of the war, with seven units being dispatched to the front, thirteen companies attested for the Imperial Yeomanry, many civilian Irish nurses

and doctors enrolled into the army medical services, and tens of thousands of pounds were raised through various Irish war charities. Irish battalions suffered considerable casualties with 4,879 injured, 1,800 deaths and thirty-seven officers killed.

Unveiled on 22 October 1904, the Celtic cross is constructed entirely of limestone from the Ballinasloe quarries, was designed by William H. Hill and is the work of John Maguire, who had a workshop at Mulgrave Street, Cork. The cross was hewn out of a single block of stone with Celtic interlacing well executed. The ironwork of the railing surrounding it is the work of Buckley & Son, Half Moon Street, Cork. The memorial was unveiled by the Earl of Bandon, the lieutenant of the county and city of Cork.

The story of the Boer War is linked with controversy as Boer and black African populations were devastated in concentration camps, which had an enormous effect on demography, quality of life and, ultimately, survival in the region for decades after. In this light, the Cork memorial has been targeted for destruction. On Saturday 28 December 1918 the memorial was partly blown up. The side of the monument facing the city was seriously damaged, and the other parts of the cross were blown away. The deliberate character of the deed can be judged from the fact that a hole was bored under the name panel. In this the explosive was placed. A second attempt to destroy the monument was made in 1925 but with limited success. The memorial still sits on its pedestal, its past referenced every few years depending on any ongoing research into Cork's role within the British Empire.

*Left*: Artist drawing by Henry Hill of Boer War Cork Soldiers' Memorial, March 1904.

*Right*: Present-day Boer War Memorial.

# 2. The Middle Marshes

## Tracking Through the Past: River Lee Hotel

A beautiful sculpture of the track plan of the Cork Muskerry Light Railway lies near the front door of the River Lee Hotel. The site of the hotel was the terminus in Cork and the sculpture is a reminder of the city's railway line connection into the heart of County Cork. The Cork terminus at Bishop's Marsh was a single-storey building covered by a corrugated iron roof with a long platform. The iron engine and carriage shed spanned three tracks. The first 4 miles of the line going west were very like that of a tramway. From the terminus (now River Lee Hotel) the line crossed the south channel of the River Lee in Cork city via a small bridge leading to Western Road. The iron supports for the bridge can still be seen. The initial stops were at Victoria Cross, Carrigrohane and then northwards to Leemount, Healy's Bridge and Coachford Junction.

The railway was established with the help of the Tramways and Public Expenses (Ireland) Act of 1883, which enabled companies to obtain part or all of the finance to construct a line. In 1883 preliminary meetings took place with prominent landowners, farmers and taxpayers to consider the possibility of establishing a light railway in the Muskerry area. The line was primarily built for tourists. It was to link Cork to the

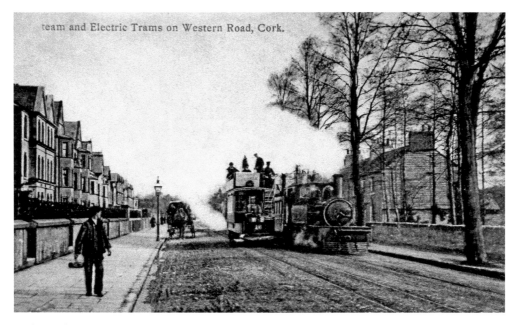

Cork Muskerry Tram locomotive on Western Road, Cork City, *c.* 1910.

tourist town of Blarney and its historic castle. Supporters of the railway line also aimed to provide improved transport for locals with livestock and farm produce between the farming area north-west of Cork and the city and for coal and minerals in the reverse direction.

There were two branch lines, one to Coachford and the other from St Ann's, near Blarney, followed the Shournagh Valley to Donoughmore. The branch line to Coachford, which was opened on 19 March 1888. Every day, the first train for Coachford left Western Road at 8.30 a.m. and the last train left at 5.30 p.m. Trains left Coachford at 6.45 a.m., 10.30 a.m. and 4 p.m. In all, the journey was 15.5 miles.

The Donoughmore Extension Light Railway began at Coachford Junction and then travelled north-west, stopping at St Ann's, Burnt Hill, Gurth, Fox's Bridge, Knockane, Firmount and Donoughmore. Passengers had to change at St Ann's for a separate line to Blarney. The first-class fare was 2s and 6d and third class was 1s and 10d. The first-class compartment had padded seats covered in red velvet upholstery. In the third-class compartment the seats were of varnished wood and ran the length of the carriage. Whenever an important match was played in Coachford, great crowds travelled on the train. All the freight arrived by train: porter and whiskey, groceries, coal and yellow meal for Coachford and Carrigadrohid. Pigs were carried to Cork by train for the city's bacon factory.

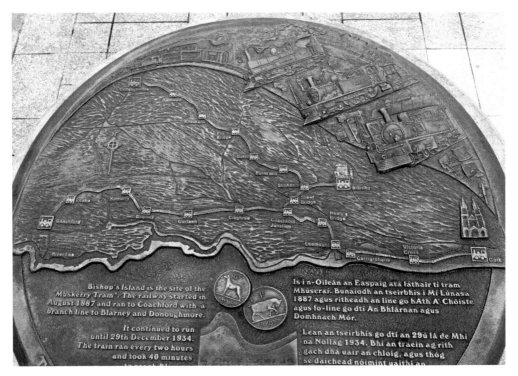

Map of Cork Muskerry rail line from a piece of sculpture, now marking the site of the city terminus at the River Lee Hotel.

## From Inner to Outer Space: Lee Maltings

The complex of buildings known as the Lee Maltings, now the home of the Tyndall National Institute, forms one of the most significant surviving industrial sites in Cork city, dating back to the eighteenth century. The complex incorporates the original site of flour mills, a brewery, a malting operation and related storage, residential and other facilities. The Lee mills were the largest water-powered flour and corn milling installations to become established on the north channel of the River Lee.

In 1797, Atwell Hayes granted a lease to the western part of the lands to Joseph Reeves, on which the River Lee Porter Brewery was erected, and which operated until 1813. Beamish & Crawford (B&C) purchased the River Lee Porter Brewery in 1813. The greater part of the existing six- and seven-storey buildings were entirely rebuilt on the site of the original mills by Beamish & Crawford before 1831. The Lee Maltings buildings were purchased by UCC from B&C in 1968 and work commenced on converting the existing buildings for university laboratory and teaching use, as well as the provision of an indoor sports facility and the original location of the UCC Granary Theatre. It is now the home of the Tyndall National Institute, which specialises in ICT hardware and systems and operates globally to facilitate and enable research, development and innovation in Ireland consistent with national priorities.

Tyndall has built up extensive experience through working on space-related research and development projects for many years. Tyndall acts as a microelectronics technology support laboratory to the European Space Agency, under which it provides expertise and evaluation services to the ESA in the areas of component and integrated circuit

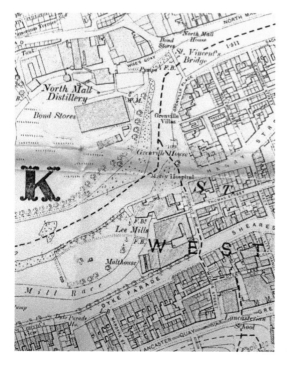

Map of Lee Mills and environs, 1900.

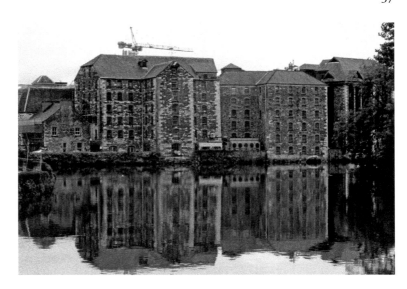

Tyndall Institute,
formerly Lee
Maltings,
present day.

quality and reliability. Tyndall also conducts evaluations of new technologies, materials and assembly processes to assess their suitability for use in the space environment. In addition to its work with the ESA, Tyndall also works directly with leading European and international space components companies.

## Synergies of a Rising: Volunteer Hall, Sheares Street

In February 1915 the leadership of the Cork Brigade of Irish Volunteers signed a lease on a large building at Sheares Street for use as a headquarters. Tomás MacCurtain was the brigade commander. Unlike their old headquarters on Fisher Street, the building had a sufficient number of rooms to allow concurrent activities such as arms drill, map reading and first-aid classes to take place on days when training was conducted on the premises.

On Easter Sunday morning, 23 April 1916, 163 Volunteers from the Cork City Battalion, together with others from Cobh and Dungourney, paraded under arms outside of the Volunteer Hall prepared to take part in the manoeuvres that were a cover for the rising that planned to establish an independent Irish republic. After an address by Brigade Commandant Tomás MacCurtain, they marched off to Capwell Railway Station to board a train for Crookstown. However, just as they were departing, an order arrived from Dublin cancelling the operation. This was the latest in a series of conflicting orders that had been received by MacCurtain during the previous week.

That day, 23 April, members of the Cork Brigade mobilised and assembled at eight designated sites throughout the county. But when he received the latest order, MacCurtain felt he had no choice but to stand his men down and order them to return home. When Tomás MacCurtain returned to the Volunteer Hall on Easter Monday evening, he learned that the rising had commenced in Dublin. As his men had dispersed and the element of surprise had been lost, he decided that it was too late to join the fighting and that his best course of action would be to defend the Volunteers against the British Army. Negotiations between both parties, mediated by the Lord Mayor of Cork, Cllr Thomas C. Butterfield, and

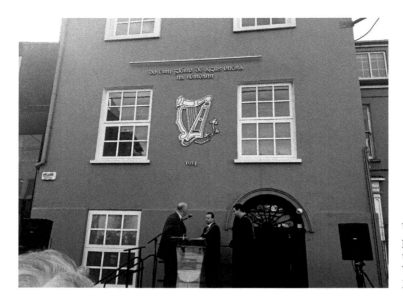

Unveiling of the plaque to mark the history of the Volunteer Hall in March 2016.

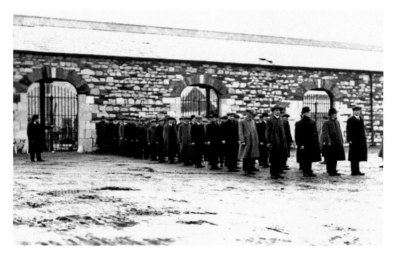

Volunteers training in the Cork Cornmarket, c. 1916.

Assistant Bishop Cohalan, eventually led to a peaceful settlement. The deal involved the Irish Volunteers agreeing to hand over their guns on the understanding they would be returned at a later date in return for being allowed to return home, but MacCurtain was arrested and detained in Frongoch internment camp in Wales along with those who fought in Dublin.

## Conservation Champion: Fenn's Quay

In the early eighteenth century, to the west of the crumbling walled town, the religious group the Quakers reclaimed and developed large portions of the marshy islands. This community had been in Cork since 1655, but it was only in the early 1700s that they were legally given the opportunity to develop their own lands. The Quaker movement

began initially in northern England around 1650 and developed out of religious and political conflict. They were also known as the Religious Society of Friends and were a breakaway group from mainstream Protestantism. With the presence of massive opportunities for trade, the Quakers established themselves in Cork city and in other County Cork towns such as Bandon, Skibbereen, Charleville and Youghal.

One of the first Quaker pioneers in the development of the western marshes was Joseph Pike, who purchased marshy land in 1696, now the area of Grattan Street. Another key player was John Haman, a respected linen merchant, who also owned land in the northern suburbs. Minor players consisted of the Devonshire family, the Sleigh family, and the Fenn family (Fenn's Quay today marks their land). In the eastern marshes, a Quaker by the name of Captain Dunscombe bought land, now the area of the multistorey car park on the Grand Parade and part of present day Oliver Plunkett Street.

Nos 2–5 Fenn's Quay comprise the majority of an eighteenth-century terrace with remarkably intact interiors. Cork City Council included the buildings in their Historic Area Action Plan, which obtained European Union funding for their conservation. The City Council played a significant role in the conservation process, in both policing the project and suggesting acceptable final users. Historical research based on the original title deeds and other deeds in the Registry of Deeds established the likely construction date of 1750. Other research traced the evolution of the terrace. A Quaker family appear to be the original developers of the site. The plan is unusual in that it is a series of parallel

 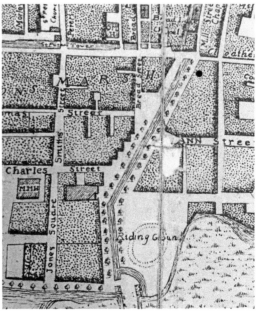

*Left*: Fenn's Quay, present day.

*Right*: Western Marshes and Fenn's Quay as depicted by John Rocque, 1773. The black dot represents the houses at Fenn's Quay.

angled layouts in response to the dictates of the then river channel rather than the more common stepped facades. The buildings were originally a single house through all floors with the intervention of shop at ground-floor level in the nineteenth century, as evidenced by remaining window heads behind the shop fascia. The project was awarded the RIAI Silver Medal for Conservation in 2005.

## Byzantine Splendour: St Francis Church

St Francis Church is a beautiful and photogenic gem of the Byzantine style of architecture and its interior is richly decorated with mosaics. Its St Antony's shrine is one of the best architectural designs in the country and, like all the mosaics in the church itself, they are the work of a Professor Umberto Noni of Rome. Mr T. F. McNamara collaborated with him in the design of this shrine and that of the choir, which were carved in Rome. Architect J. R. Boyd Barrett supervised its construction on a site that was already layered with 300 years of Franciscan history.

In the years 1730–50, evidence shows that the Franciscan Order were practicing Catholicism in three main areas in the city: Shandon and Cotner's Lane situated in the city centre between North Main Street, the Coal Market, and Duncombe's Marsh (near the Grand Parade today), which held the dwelling of a Franciscan friar. Despite the strong presence of the penal laws, by 1750 the Franciscans had moved from North Main Street and had by now set up a friary in Broad Lane, which today is part of the present site of St Francis Church. In 1771 another move was made by the friars, this time to the opposite side of Little Cross Street (again part of the present site of St Francis Church) where they built a superior church than the last between 1813 and 1831. It was here that they remained until the present day.

In July 1813 it seemed apparent that a new church would have to be built due to the increasing numbers in the congregation and the disrepair of the church. On 26 July 1813, Dr John Murphy PP laid the first stone of the new building on the previous site. The latter friary was taken down and all its contents were sold off. On 14 July 1829 the foundation stone of the new church was laid. Its architect was a Charles Cottrell of Hanover Street. To finance the building of the church, collections had to be made. Contributions were received and collected from places such as Waterford and Clonmel in Tipperary. They were also made in the city and county. Finally, on 2 January 1831 the church was opened for public worship and dedicated by Dr Murphy of SS Peter and Paul's Church.

In the years 1837, 1878, 1892, 1893 and 1894, the Franciscans bought land from Cork Corporation, which resulted in the order acquiring quite a bit of the area in front of the friary and on Grattan Street. In between the above years, the street in front of the friary was widened, the porch rebuilt, lamps and railings installed, and further improvements to the church and friary were carried out. The presence of 'Fenian' Republicans in the country caused an increase in the amount accumulated from collections.

In 1881, it was proclaimed by the Franciscan Order's civil engineer that the church and friary were unsafe due to subsidence into the city's underlying swampland. It was not until 14 June 1937 that the decision was taken for a new modern church to be built. Unfortunately, rebuilding could not commence until after the Second World

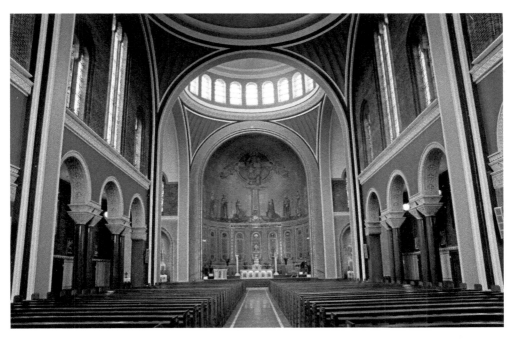

St Francis Church, present day.

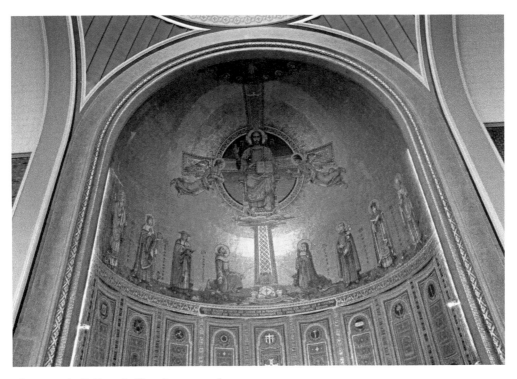

Altar mosaic, St Francis Church, present day.

War as there was a lack of building materials. Therefore, on 31 July 1949, Bishop Daniel Cohalan laid the foundation stone of the new church on the site of the previous demolished structure.

## A Slice of Paradise: North Main Street

In the sixteenth-century walled town of Cork the centre of the settlement was known as Paradise Place. Here stood a castle at the head of a canal, which flowed by the present Castle Street. It does not have a detailed history other than that it was built by one of the Anglo-Norman descendants of the Roche family. The castle is referred to in records by several names – The Parentis, The Golden Castle, The Paradise Castle and Roche's Castle. There is an architectural term 'Paradise', now obsolete, meaning 'stone parapet in front of a public building' and also applied to spaces adjoining. Reputed to be a circular tower, it was used as a mint in the reign of King John, and continued as such to the reign of Edward IV, when it was known as Dundory, the fort of gold, or the Golden Castle. Down to around 1910 a rent was paid to the Corporation of Cork, whereby at that time the Roche line was broken and the Corporation took over the site.

The elegant Exchange or Tholsel was built on the site of Roches Castle. It was an important building of two storeys. On its opening in 1710 the council ordered the upper-floor room be established as a council chamber with liberty for the grand jury of magistrates and landlords to sit. The lower part was used for commercial purposes, where

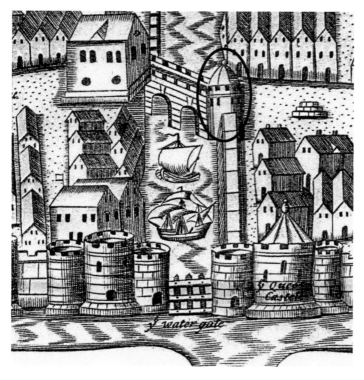

Sketch of Watergate and Roches Tower (centre right), c. 1600.

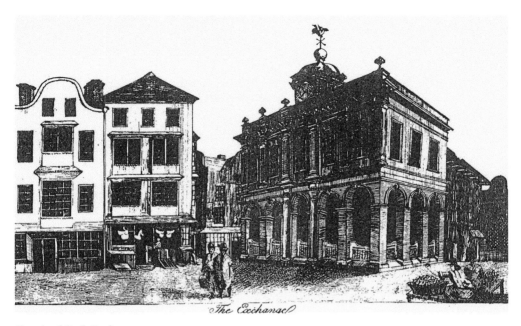

Sketch of Cork Exchange, *c.* 1750.

a pedestal known as 'the nail' was used for making payments (still in existence in Cork City Museum). In later times the room was used for public sales. A figure of a dragon made of copper and gilt surmounted the cupola of the building as a weathervane. It was presented to the Royal Cork Institution in 1836, and removed on two occasions, but recovered first with the loss of the tail and later without the head. It was finally disposed of in 1865.

The Exchange declined as a market in time, through the erection of a Corn Market on the Potato Quay (popularly known as the Coal Quay) and improved facilities for the transaction of business offered to merchants. The building, however, continued in use as an assembly room and auction mart, with part of the premises let for shops and printing offices. Some adjoining houses, the first erected in the city under the Tontine system by a Mutual Building Society, were also occupied by stationers and kindred traders, a circumstance that tempted Corkmen – never at a loss for a nickname – to bestow on Castle Street the subtitle Booksellers' Bow. The People's Hall was eventually occupied by the Catholic Young Men's Society.

## An Unfinished Monument: St Augustine's Church
A report on the 'State of Popery' in 1766 also describes an Augustinian friary in Fishamble Lane. This lane no longer exists but in present-day terms was located near Liberty Street. In 1770 their chapel was in a very bad state of repair. The head of the order, Father Edward Keating, selected a site in the parish of SS Peter and Paul but this was rejected by the bishop. He stated that a new chapel could not be built in this parish or in the parish of Shandon due to the presence of other chapels and convents. Hence a new site was chosen in the south of the parish on Brunswick Street. On 20 November 1780 the foundation

stone was laid. Seven months later, on 4 June 1791, the bishop complied with the Rome mandate by opening the church in the presence of Father Edmund Keating himself.

In 1791 the Augustinians rented land from a nearby grocer, where they built a new sacristy. In 1872 the Augustinians built two new priory houses on Great Georges Street (now Washington Street). With the growth in population, it became clear that the chapel would have to be extended again in order to cope with the crowds. However, a shortage of funds meant building could not take place. Approximately fifty years later, the finance was finally raised and in 1944 the present-day church was opened.

Today's church took seven years to complete. During these years, a major problem encountered involved the marshy land on which the building was to be constructed. In addition, there was a lack of raw materials for building. This was due to the Second World War, which restricted the supply. Consequently, there was a severe shortage of steel for the roof, and stone. Stone had to be attained from the blown-up remains of a stone viaduct in Mallow. The design chosen was a Roman style. An absence of pillars means the altar can be seen from any part of the interior. The doorway adjoining Washington Street today was designed in an Italian style. Its sculptor was Mr Christopher Fitzgerald. The lack of funds led to many unconstructed features; for example, a large bell tower was supposed to form an elegant entrance, but today, a narrow tunnel forms the Grand Parade entrance instead.

St Augustine's Church, present day.

Our Lady's Shrine, St Augustine's Church.

## The Street of the Yellow Horse, Grand Parade

One of the more interesting felonies committed within the city centre in 1862 was the destruction of the hollow yellow horse of George II at the intersection of the Grand Parade and the South Mall. A symbol of British colonialism in Cork for just over 100 years, it was to meet its demise in this year. Originally planned for in October 1760, Mayor Thomas Newenham announced that any subscriptions towards the creation of the statue of George II would be greatly appreciated. In the same month, the statue was completed by designer Mr Van Oost and on 21 April 1760 the completed statue of King George was landed at the city's eighteenth-century Custom House (now part of the Crawford Art Gallery, Emmett Place). In late August 1760 it was decided to erect the equestrian statue with its pedestal on a specially constructed arch on the south side of Tuckey's Bridge (centre of present-day Grand Parade and marked by Berwick Fountain). In late September 1760 it was further decided to enlarge this bridge so that carriages could pass on each side of statue. In mid-February of the following year, 1761, cast-iron rails around the proposed site were attained and a cast-iron copy of the coat of arms was attained. However, it was only in the following year, 1762, that the leaden statue of George II was actually placed on Tuckey's Bridge.

The statue was eventually moved to its nineteenth-century location around 1860, when Berwick Fountain was constructed on the site. The fountain is named after Walter Berwick

who came to Cork to preside as chairman of the quarter sessions. He gave a gift of the fountain to the city. Sir John Benson was given the honour of designing the fountain and took six months to come up with a plan. On 27 August 1860 Cork Corporation laid the foundation stone of Berwick Fountain.

On 9 March 1862, during the middle of the night, it is reputed that a person climbed over the security railings around George II and hacked away the supporting metal beam holding the hollow horse in place. The horse collapsed onto the adjacent street and was hacked apart and broken into pieces by the general public. Part of the pedestal has survived the test of time and is on display in the present city museum in Fitzgerald's Park. The Irish derivative on the place name plaque for the street is Sráid an Chapaill Bhuí, or 'Street of the Yellow Horse'.

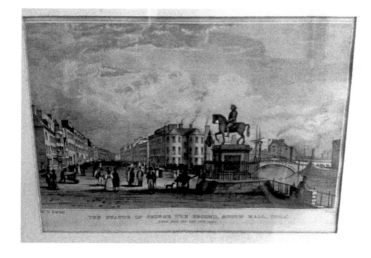

George II statue on the Grand Parade, c. 1830.

Former site of George II statue today, now that of the National Monument, erected in 1906.

## A Public Resource: the Children's Library

Cork city pioneered children's library services in Ireland. It was the first public library in Ireland to introduce a collection specifically for children, in 1893, at the premises which were then located at Nelson Place (now Emmet Place). The purpose-built Carnegie Free Library, which opened on Anglesea Street in 1905, included a dedicated children's department and reading room. Fifteen years later, the library became a casualty of reprisal burnings by Crown forces in the city on the night of 11 December 1920 at the height of the War of Independence. The building and the stock on site – approximately 14,000 books – were engulfed by the fire in the neighbouring building, the City Hall. Considering the competing urgent demands placed on the local authorities in the wake of this decimation of the city centre, that a library service was re-established on a temporary site in Tuckey Street was due largely to the Herculean efforts of the then librarian, James Wilkinson.

Wilkinson issued an appeal for book donations, which yielded an extraordinarily generous response from the national and international community. The accession ledgers in which acquisitions to stock were recorded continue to be housed by the Central Library's Local Studies Department and make for fascinating insight into the history of reading in Cork city. Some notable donors were Charlotte Bernard Shaw, wife of the playwright George Bernard Shaw; Mrs W. B. Yeats, wife of the poet; and novelists Edith Somerville, Lennox Robinson, Daniel Corkery and Annie M. P. Smithson. A letter written by Wilkinson in 1923 to the superior of St Brigid's Convent, Sydney, apologising for the delay in acknowledging receipt of the order's financial donation captures the turmoil of

Cork City Library, Grand Parade, present day.

Former pillars of Cork Carnegie Library, Tuckey Street, present day.

this historic period: the delay 'was due to the fact that the cheque and list of donors was transmitted by Professor A O'Rahilly at a time when he was an interned prisoner, who sent the cheque on to me, but not the list of names'.

The library transferred to its present location on the Grand Parade in 1930 but a curious relic of the Carnegie Library may be seen on Tuckey Street. Two pillars embossed with the Irish language translation of Carnegie Library on the cap stones are visible, though, as they set back from the street, largely unnoticed. Whether these were salvaged from the library after the burning, or how they were conveyed to their present location, is unknown.

## The Square and Compass, Masonic Hall

The Masonic Hall is located at Nos 25–27 Tuckey Street. This building has been the headquarters for Freemasonry in the province of Munster (county and city of Cork and County Kerry) since 1844. This is an end of terrace, seven-bay, four-storey building, with a slate pitched roof. Archival material on the walls of the lodge denotes that it was built *c.* 1770, in the then recently developed Tuckey's Street (1761) and is shown as 'The New Assembly Rooms' on a city map of 1771. The ground, first and mezzanine floors of this building were constructed at this time: there were three shops on the ground floor, generating income for the maintenance of the building, while a sweeping staircase led to the assembly room (now the lodge room) and upward to the gallery (now a storage room). The upper floor was available for rental by various societies and clubs, among them the First Lodge of Ireland, which in 1844 purchased the entire building for its use, and that of the quarterly general meeting of the province. In 1925, when all other city lodges came together at this premises, the top floor was added (now Royal Arch Chapter Room) to

provide additional capacity. From the outside this building may seem unassuming, even austere, but behind its walls lies an interior of vast beauty and history.

In the supper room on the ground floor there are many display cabinets containing historic items relating to important events in the life of the Masonic Order in Cork, Ireland, and overseas, including old Masonic aprons, levels and badges dating back to the eighteenth century. One of the levels displayed there was used at the laying of the foundation stone of St Patrick's Bridge and St Fin Barre's Cathedral. A section of this room is devoted to the Hon. Mrs Elizabeth Aldworth (nee St Leger) who was reputedly the only female ever to be admitted to the Masonic Order.

The lodge room is reached via the original 1770 staircase, which is lined with fascinating pictures depicting many important historical events in Cork city. On entering the lodge room it feels as if one has stepped back in time. The stalls and paneling are over 300 years old having come from the former St Fin Barre's Cathedral (demolished in 1865). The armorial banners on the walls are the coats of arms of some of the highest-ranking members in the Freemasons; those over the stalls belong to current stallholders, while those higher up towards the ceiling belonged to members now departed. The figures that surround the large mosaic are the plaster casts used in making the figures of the four evangelists, which surround the west window in St Fin Barre's Cathedral, and examples of craftsmanship by Cork firms past and present are on display on all sides. The lodge room is used every month from September to May by the seven lodges, which meet in Cork city.

Lodge Room, Cork Masonic Lodge, Tuckey Street, present day.

Masonic Lodge motif,
Lodge Room, Tuckey Street,
present day.

## A Unity of Purpose: Unitarian Church

The Prince's Street Unitarian Church was built between 1710 and 1717 as a dissenting Protestant meeting house and is still home to Cork's Unitarian congregation. Some of its distinguished parishioners include Revd Thomas Dix Hincks, founder of the Royal Cork Institution (precursor to C.I.T), artist Daniel MacAlise, and Lord Mayor Richard Dowden. The Father Mathew Temperance Agreement was signed in this church in 1839.

Dating to the early eighteenth century, this church is recorded as the oldest place of worship in the city. It was built to replace an earlier meeting house at Watergate Lane in the medieval town, which has become too small for the congregation. It was one of the first structures built outside the medieval town walls on the eastern marshes. The site for the new church was found in the recently laid out streets of the expanding city.

The plan and layout differs substantially from contemporary churches of the Roman Catholic, Church of Ireland and Presbyterian traditions in the city. The interior is essentially square, surrounded on three sides on both ground and gallery levels by congregation seating. It is an auditory church, designed to allow the congregation to hear the preacher or clergyman, rather than follow a service at a distance. Still in its original use, the building is a significant contributor to the social and architectural heritage of Cork.

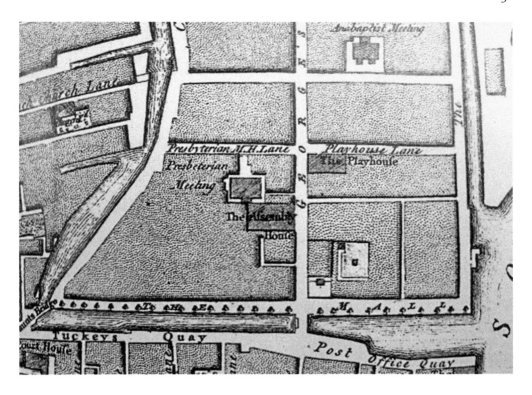

*Above*: Meeting House, as depicted on John Rocque's map of 1773.

*Right*: Unitarian Church, Princes Street, present day.

# 3. The Eastern Marshes

## A Sailor's Resting Place: St Paul's Church

Work on St Paul's Church began on 11 May 1723. It was built by subscription of £1,897 by parishioners and land granted by the Corporation of Cork to Peter Brown, the Protestant Bishop of Cork from 1709 to 1735. The Corporation also voted £300 towards the project, and the church was finished with the aid of the tax levied on coal and culm by Act of Parliament.

The church took six years to complete and was built on an island surrounded by marsh and water beyond the old town walls. It is an oblong building without tower or spire. The building is Grecian in style with a very beautiful interior capable of accommodating more than 600 people. The stucco work on the interior is worthy of notice: it is said to be the work of Italian prisoners taken during the Napoleonic Wars. This was a time of great expansion by the Church of Ireland and St Anne's Church, Shandon, was built the year before. The first service in St Paul's was held by Revd Edward Sampson on 9 October 1726. By 1781 the parish of St Paul's had both a rector and a curate.

Shortly after the initial building of the church was completed, the clergy decided to delineate a parish for the new church, which would offer a maintenance for Revd Sampson. A further document from Cork Corporation to the parishioners, dated 1 September 1737, ordered a 'draft of deed be prepared by the parishioners of St Paul's Church for the grant to the Mayor and Constables and their successors as trustees of the ground before said church for a burial place for strangers and others who die in the parish, such as the mayor and Corporation shall recommend as object of charity to be buried without fees'. In other words, a pauper's graveyard was created. This led to a large number of seafaring men being interred in the churchyard – the area being the centre of local shipping. Underground crypts were the resting places of a more gentrified citizenship.

Like many Protestant churches in the city, St Paul's thrived for 200 years but, like the community, it began to wither in the latter half of the twentieth century. The church was deconsecrated in 1950 when Guy's Printers took it over and it fell into ruin when the company left in 1997. It is also generally believed that some table tombs were removed and or demolished.

The western side of the graveyard was levelled, and in the late 1960s and early 1970s headstones were redeposited on the eastern side of the graveyard. Some limited ground works for the new paving and signage in the former graveyard as part of the current retail development were undertaken in June and July 2008. The need for minimum disturbance of the archaeological remains present on the site dictated the work permitted. The church is now the retail premises of Fifty Degrees North as part of the TK Max retail complex with its unexcavated underground crypt and Italinate ceiling, beautiful remaining features.

---





## French Connections: Huguenot Graveyard

The north-eastern marshes became a significant area of development for the Huguenot congregation in Cork. By the eighteenth century in Cork, over 300 Huguenots had established themselves in Cork city. Many of them worked as tradepeoples, especially in the textile industry and in the manufacture of linen and silk. The Huguenots were also involved in property development and one of the first Huguenot families to develop property was Joseph Lavitt, whose family were primarily involved in overseas trade and sugar refining. Lavitt's Quay was constructed in 1704 and echoes the Huguenot's past presence in the area. The areas of present-day French Church Street, Carey's Lane and Academy Street in the city centre today are located at the core of the Huguenot quarter with the name 'French Church' also reflecting their involvement in townscape change in Cork in the early eighteenth century.

The growing Huguenot community in Cork initially worshipped in temporary locations but by 1712, members were able to build their own church or temple on Lunham Street, now French Church Street. In 1733 they acquired an adjoining almshouse, which they removed, using the area as a burial ground. For just over 100 years the Huguenots worshipped in French at their church. At first Calvinist (nonconformist) services were held, but by the 1740s worship conformed to the Established Church (Anglican). By the early nineteenth century most Huguenot descendants no longer needed language services. Huguenot worship at the French Church ceased in around 1813.

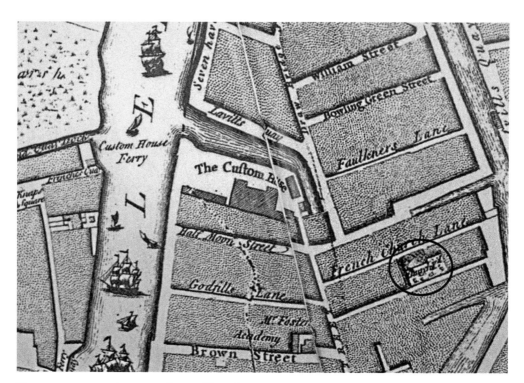

Huguenot graveyard, 1773, as depicted by John Rocque.

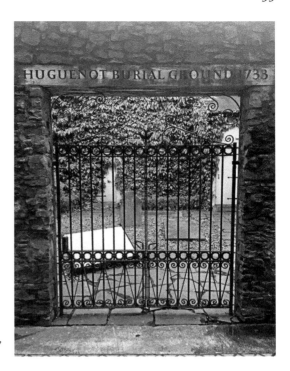

Huguenot graveyard, established in 1733,
present day.

The French Church was used for primitive Wesleyan Methodist worship for most of the nineteenth century. In 1845, the original building was replaced by a new larger chapel that extended from French Church Street to Carey's Lane. From around 1901 the building was used for commercial purposes. The last known burial took place in that year.

This surviving portion of the burial ground has been preserved as a tribute to the Huguenots who made an important contribution to the life of Cork. It was acquired by Cork City Council in 2007 and transformed into a memorial garden during the following year. Two headstones had survived and when removing debris built over the years, archaeologists discovered other headstones and the remains of tombs. These marked the burying places of Huguenots and their descendants. Methodists also were interred here from the nineteenth century. Unfortunately, the church and burial records have not survived. Some of those known to be buried here included members of the following Huguenot families – Goble, Hardy, Jappie, Le Grand, Madras, Malet, Perrier and Pique. Protecting the burial ground from the street is an early eighteenth-century wall, dating to the period when this area was settled.

## An Educational Institution, Jameson Row

The first half of the nineteenth century became a 'golden era' in the city's cultural history, a time when the city itself was alive with artistic activity. The concept of educating the general public was deemed a key component in improving the social conditions of British and Irish citizens living within large urban settlements. Cultural institutions emerged to lead the way in many prominent urban British centres, all aiming to advance moral

and intellectual values of its members. The Royal Cork Institution was founded in 1803 by Revd Thomas Dix Hincks, minister of the Old Presbyterian Church in Princes Street. From small beginnings at premises on Jameson Row on the South Mall, the Royal Cork Institution planned and maintained itself as a British-supported research and teacher centre for over seventy years. With energetic membership, the institution was based on the interests of people and offered no certificates or qualifications. Courses were given along with public lectures on various aspects of science and the application of scientific principles to industry and agriculture. In essence, the institution pioneered the concept of adult education.

The library of the Royal Cork Institution helped in the cultivation of wider interests, and provided a specialised service to doctors and lawyers. A botanic garden was established at Ballyphehane, now the site of St Joseph's Cemetery. In 1829, the Institution became the first public body to formally petition the government to establish a provincial academic institution in the city. From its foundation until 1826, the institution was in receipt of an annual grant from the Westminster Parliament. Compensation for the withdrawal of this grant came in the form of the British government presenting the premises of Cork's former eighteenth-century Custom House (now the Crawford Municipal Art Gallery on Emmett Place) to the institution. This provided greater space for the wide range of activities. The most popular activities included demonstrations in chemistry, electricity, botany and mineralogy. Science had the vibrant appeal of being an amateur study plus

Jameson's Row, South Mall. The initial premises of the Royal Cork Institution cost £2.

the curiosity of being something new. Its repository of classical casts also contributed powerfully to the early artistic training of Corkonians.

In the 1830s, the Royal Cork Institution influenced the British government, through public appeal, in its decision to establish a university not only in Cork but in Galway and Belfast too. The directors of the Royal Cork Institution were heavily involved in the establishment of the Cork School of Art in 1850 and the Athenaeum, another venue for promoting the fine arts and science. The Cork Industrial Exhibition of 1883 provided an excellent occasion to highlight the need for a new school of art.

By 1883 the Royal Cork Institution was open every day with an annual subscription of one guinea. The library was extensive and consisted principally of scientific works. Perhaps one of the last campaigns of the Royal Cork Institution was the structuring of a Cork School of Music in 1886. The school was located at No. 51 Grand Parade. Through directories of Cork around 1890, the Royal Cork Institution (RCI) was not noted as a city institution, thus marking its eventual demise as a prominent educational resource for Victorian Corkonians. However, the ideas of the RCI on the 'diffusion of knowledge' were to live on in the early twentieth century in the form of the Crawford Municipal Technical College in 1912, which eventually transformed into Cork Regional Technical College in 1974, and subsequently evolved into the Cork Institute of Technology.

## The Owls of Pembroke Street

Two owls on a coffee shop entrance and a date of 1792 are the only remnants of the Cork Subscription Library. Unique in the country, the library was founded at a time when books were scarce, expensive and not easily attainable. The Cork library catered successfully throughout its long period of use for the reading wants of many generations of Cork men and women. The brightest and best in the intellect of Cork had been closely associated with the Cork Library ever since its inception. In 1792, the library was based on Cook Street to begin with and then new premises were designed by noted architect Thomas Deane.

In 1801 the library had eight life members and 143 ordinary members. The committee for that year comprised notable Cork personages: Dean St Lawrence, president; Dr John Longfield, vice-president; Doctors Charles Daly, Richard Walsh, J. Bennett, T. Bell; and Messrs A. Lane, S. Wiley, J. Spearing, St Leger Aldworth, W. Trant, T. Rochfort, S. Richardson, P. Stacpole, Mr Maxwell, H. Wallis, B. Bousfield, N. Mahon and E. Penrose. Dr T. Westropp was treasurer.

The library catalogue in 1801 ran to a volume of thirty-one pages and had 627 items – History, Antiquities and Geography (146), Biography (thirty-eight), Politics and Political Economy (twenty-one), Morality (thirteen), Law (four), Divinity, Sermons (seven), Metaphysics and Arts (sixty-two), Medicine, Surgery, Anatomy and Chemistry (eighty-three), Natural History, Minerology, Botany, and agriculture (twenty-six), Voyages and Travels (eighty-four), Belles Lettres, Poetry, Criticism, and Miscellany (108), Novels and Romances (twenty-five), and Dictionaries and Grammars (ten). By 1820 the number of books in the catalogue had risen to 2,013 with membership growing to 385.

Any person wishing to become a member of the library had to be proposed by a library member and seconded by another. After his and their names had been exhibited for five

*Above*: Front façade of former Cork Library, South Mall, present day.

*Left*: The owls of Pembroke Street, present day.

days in a part of the library, the subscription for the year of one guinea, together with the admission money of half a guinea, had to be deposited with the treasurer. The proposed member was then balloted for in committee, and if a majority of those present appeared in favour of him, he could be admitted. On signing the rules, he was be entitled to all the privileges of a member of the society. The names of ladies, however, were not to be posted up, but kept in a book provided for that purpose. The library was to be open for members of the library to read and send for books from 11 a.m. to 5 p.m. from 1 February to the 1 November; and from 11 a.m. to 4 p.m. from 1 November to 1 February except Sundays, Christmas Day and Good Friday. Members could only take out one book unless an additional subscription of half a guinea was paid for an additional book.

By the year of the Cork Library's closing in 1938, the reading room had upwards of 20,000 volumes of general literature, the daily and weekly newspapers, periodicals, illustrated papers and magazines. The library contained a writing room, ladies' rooms, and gentlemen's smoking room. The latter was situated in a central position with a spacious and comfortable writing room. The members of a subscriber's family were entitled to the full privileges of the library, while the annual subscription was £2.

## Feis Feasts of Culture: Father Mathew Hall

In the late nineteenth century, the 300 members of the Total Abstinence Society attached to Holy Trinity Church hosted recreational events in a nearby building. On 30 January 1907 the present hall was opened in what was then Queen Street. There was a good auditorium for plays and concerts and plenty of rooms for activities such as a billiard room, a card room and a reading room. For a time attempts were made to run pictures – it was called a Picturedrome. The Christmas Pantomimes became popular – the cast being hall members and monies that were made defrayed expenditure. At different times, members organised dramatic societies, bands, orchestras and choral groups. Classes were held in cookery, sewing and needlework, gymnastics and first aid. Outdoor recreation comprised hurling, football and cycling. Teams were entered in the Cork County Championship and local leagues. The positive relationship with the GAA led to frequent permission to run tournaments in aid of the hall.

Feis Maitiú began its journey in 1927 and was the most important cultural event not just in the city and county, but in the entire country. The first Cork Feis lasted four days and had one adjudicator for competitors in speech and singing. In 2017 the event was held across eight weeks with almost 12,000 participants taking to the stage in over 300 classes.

In 1943 Father Mathew Flynn became president; he rearranged the auditorium and furnished it with theatre seating, put in a new balcony and improved the stage facilities. It was not easy to meet the debt incurred but the burning of the Cork Opera House (1955) left the newly conditioned Father Mathew Hall as the only regular theatre in the city. Companies such as the Southern Theatre Group and Carol Clopet Productions had fixed tenancies; local producers like James Stack and J. N. Healy did all their work there so that, taking the Feis and Pantomime into account, there were not enough dates to meet demands.

The Opera House reopened and the fortunes of the Father Mathew Hall decreased drastically. Regular bingo made it eventually possible for Brother Paul O'Donovan to repaint, reconstruct and recondition the building into a first-class theatre and social hall.

 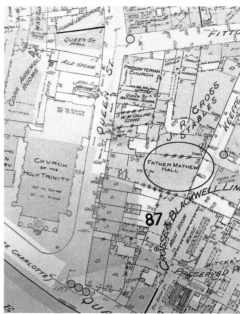

*Left*: Father Mathew Hall, present day.

*Right*: Goad's insurance map of Queen Street, now Father Mathew Street, with Father Mathew Hall, 1915.

Pantomime and locally produced plays returned but with the advent of the Everyman Palace in the early 1990s, the focus of local theatre moved to the MacCurtain Street. The mainstay of the Father Mathew Hall today is the Feis Maitiú, which gives performers young and old a chance to take on various Feis classes in a welcoming environment with encouraging feedback by international jurors.

## Success on the Quay: the College of Commerce
One hundred years ago, the Cork Municipal School of Commerce was housed in premises, built as an ordinary dwelling house on Jameson Row in the South Mall, and was deemed a 'dangerous structure'. Their work was hampered by rooms being of insufficient size for classes; ventilation was unsatisfactory and the cloakroom accommodation was inadequate.

In his principal's report of 1930, D. J. Coakley noted that the School of Commerce was well placed to provide a more than satisfactory commercial education. The school also aspired to provide full-time day continuation education for young people between fourteen and sixteen years, commercial education for students of sixteen years of age and upwards, and part time classes to meet the specialised requirements of employees. In the previous two years, D. J. Coakley had been planning an expansion of the college through attaining new premises. Previous end of year reports had criticised the lack of space to expand the operation.

At a meeting of Cork Corporation in mid-July 1930, the Lord Mayor F. J. Daly, presiding with the City Manager of Cork Corporation, Philip Monahan, announced that a unanimous donor who had purchased a site on Father Mathew Quay for £2,500 had offered it to the Corporation for the erection of a new School of Commerce. The Corporation accepted the offer, and passed a resolution of thanks to the generous donor. They passed on the offer to the City of Cork Vocational Educational Committee. The donor was William T. Green. William was very interested in the commercial and educational life of Cork city. He was elected president of the Cork Incorporated Chamber of Commerce and Shipping in 1904. He was involved in the original proposal to the Department of Agriculture and Technical Instruction to provide a School of Commerce for the city.

On 24 June 1935, in the presence of a large and distinguished gathering, Thomas Derrig TD, Minister for Education, laid the foundation stone of Cork's new £60,000 Municipal School of Commerce and Domestic Science. The attendance included William T. Cosgrave TD, who travelled especially from Dublin for the occasion. The site and the foundation stone were first blessed by Revd J. Canon Murphy, St Finbarr's South Chapel. The minister congratulated the architect Henry Hill, and the builder Sisks, on the 'admirable, yet simplicity of the building'. It was, he noted, a source of satisfaction

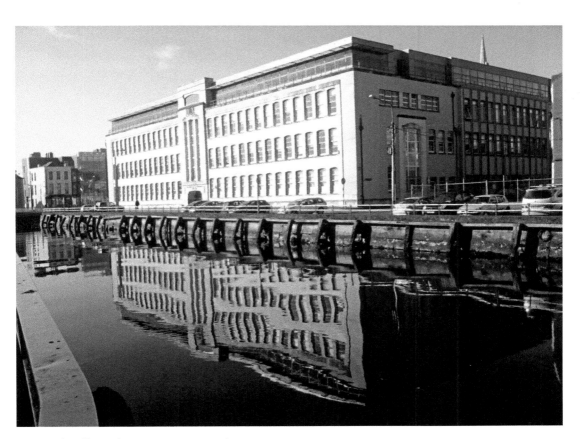

Cork College of Commerce, present day.

to him to record that workmen and tradesmen of Cork played such an important part in the building of the school, and the materials and fittings would as far as possible be Irish. Speaking at the subsequent luncheon in the Victoria Hotel, the minister noted that the constant demand for the extension of technical schools and for the erection of new ones was a 'sure tale of progress'. A problem he highlighted was the training of girls for domestic service. It was his opinion that these girls, if properly trained, could obtain suitable positions in this country. He was in full agreement with the chairman of the County Cork Vocational Committee that to raise the position of the domestic servant in this country was a matter of great importance. To succeed in this endeavour 'they can only do so if the girls themselves are prepared to take out a full course of training, which he was sure all the Vocational committees, throughout the country would only too glad to supply'.

## The Heart of Cork: Former Jewish Synagogue

The former synagogue building on South Terrace had been in use since 1905 and served a Jewish community that first settled in the city in the 1880s until 2016. The dwindling numbers of recent years made maintaining the minimum number of male adults needed for regular services very difficult.

The Cork Jewish Congregation was founded around the year 1725 with a shochet and cemetery. It comprised Ashkenazi and Sephardi Jews engaged in import and export. By 1871 there were nine Jews in Munster. During the Russian oppression, which preceded the May Lass of 1881, several Jews of Vilna, Kovno and Ackmeyan, a Lithuanian village, came to live in Cork. A congregation was formed at the close of 1881 and Meyer Elyan of Zagger, Lithuania, was appointed shochet, reader and mohel. The community had close links with those of Dublin and Limerick.

Several of the earliest arrivals from a cluster of *shtetls* in north-western Lithuania settled in a group of recently constructed dwellings called Hibernian Buildings, Monarea Terrace and Eastville, off the Albert Road, around 1880. Much of the streetscape is as it was more than a century ago when the first Litvaks arrived. Hibernian Buildings was a triangular development of 100 or so compact and yellow brick on street dwellings. Each unit consisted of four rooms, including a bedroom up in the roof. The O'Flynn Brothers, based in Blackpool, were responsible for the construction of the Hibernian Buildings as well as the Rathmore Buildings, St Patrick's Hospital, the Good Shepherd Convent, Magdalen Asylum, additions to Our Lady's Hospital, a new presbytery at the North Cathedral, and the Diocesan College at Farranferris.

Immortalised by the name 'Jewtown', Albert Road and the area of the Hibernian Buildings have been imbued by the story of the Jewish community. Seventy Jews prayed in a room in Eastville. Around the year 1884, a room was rented in Marlborough Street from the Cork Branch of the National League. A synagogue was fitted up in the offices there. Premises were finally acquired at No. 24 South Terrace in 1905. The number of Jews in the city and county combined rose from twenty-six in the year 1881 to 217 in the year 1891. At its height, the Jewish community in Cork in the mid-twentieth century comprised sixty-five families with as many as 400 members.

*Left*: Former Cork Synagogue, South Terrace, present day.

*Right*: Former interior of the Jewish synagogue, South Terrace, present day.

## A Hospital for All: South Infirmary

Fronting Anglesea Street is the beautiful old building and Victorian entrance door of the Victoria Hospital. The South Infirmary Victoria University Hospital Ltd came into existence on 1 January 1988 as a result of the amalgamation of the South Charitable Infirmary and the Victoria Hospital.

The South Infirmary was opened in 1762 and was established by Act of Parliament. It was funded through subscription and recorded 1,000–1,200 patients annually. A hospital visitor, John Howard, in 1788 reported that 'the wards of both the men and women are clean and fresh and had all the windows open. None of the beds were furnished with sheets and the blankets were dirty and torn. Allowance for diet (potatoes and milk) is 2*s* per week but 6*d* of it is paid to the nurse. Mr Robert Bell, George Daunt and Thomas Harris, surgeons attend every day, without fee and reward'.

Dr John Woodruffe was surgeon to the South Infirmary, 1811–59, and was the founder of the first School of Medicine in Cork in 1811. His school offered courses in anatomy, physiology, the theory and practice of physics and clinical surgery. The school was recognised by the Royal College of Surgeons, London. Medical officers of the Army and Navy are invited to attend gratis. It began its life on Margaret Street, moving to the Old Blackrock Road, Cove Street and finally in 1837 to Warren's Place (now Parnell Place).

In 1835, the South Infirmary had 381 interns and 14,354 externs, and by 1861 the figure had risen to 600 interns and 16,000 externs. In 1861, the County Infirmary at Mallow was moved

to Cork and merged with the South Infirmary as the 'South Charitable Infirmary and County Hospital'. A new building was constructed with the old buildings subsequently used as a militia barracks from 1862 to 1885; these were then taken over by the County and City of Cork Hospital for Women and Children. By 1899 the Sisters of Mercy took over administrative control of the South Infirmary complex under the Joint Committee of Management.

The Women and Children's Hospital opened in a house on Union Quay on 4 December 1874. There were twenty-four beds and an extern department and 128 patients were treated in the first year. Owing to increasing numbers, they moved to No. 46 Pope's Quay on 31 October 1876. This hospital comprised twenty-five beds and an extern department. The move to the South Infirmary occurred in 1885 and shortly afterwards an efficient training system for nurses was established. In 1901, the name of the hospital was changed to the Victoria Hospital for Women and Children.

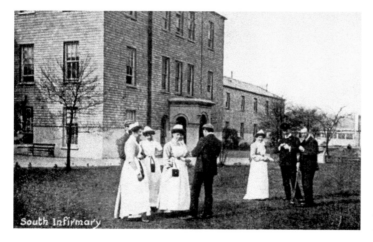

Postcard of South Infirmary, c. 1910.

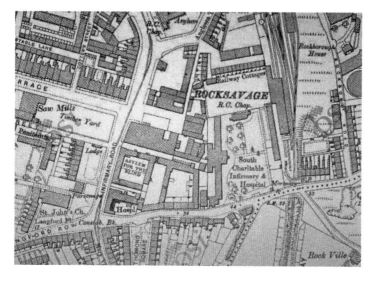

Map of the grounds of South Infirmary, c. 1910.

## A Bridge of Heritage: Parnell Bridge

Each of the city's bridges offer an interesting story in the historical debate on the growth of Cork city. Parnell Bridge is a case in point. During the preceding century before 1830, the corn industry in Cork was an extensive market and most of its trade was done in Corn Market Street. As corn was a prosperous trade, it was decided by the council of the city that a new building should be built to deal with the demand. It became known as the Corn Exchange and was located where the City Hall stands today. To oversee the Corn Exchange, a group of people named the Corn Market Trustees, established by an Act of Parliament, was set up. Their main job was to look after finances relating to the trade and the building.

A key problem to the trustees was access to their building – if a person desired to get there, one would have a difficult journey. That person would have to cross at Parliament Bridge and travel up the quays. The topic of building a new bridge from Warren's Place (now Parnell Place) to the new Corn Exchange at Sleigh's Marsh was discussed regularly among the trustees. The go-ahead was given and the project began. Various contributions were given from distinct groups such as the government of that time, the trustees and the Corporation of the city. Mr Alexander Nimmo, a well-known engineer in the city, along with Sir Richard Griffin, a trade official from his board, had to oversee the operation. A solid stone structure with a centre lifting arch was the ideal design. Thomas Deane (later to become knighted and become Sir) was given the job of engineer. It was on 3 June 1830 that the keystone of the new bridge was put into place. The new bridge was named Anglesea Bridge in honour of the Marquis of Anglesea, a viceroy for Cork. It had two oval-shaped arches with a large waterway spanned by a drawbridge, which would let shipping through.

In December 1863 the mayor, John Francis Maguire (founder and patron of the *Cork Examiner*), called for a replacement of the old Anglesea Bridge at a Cork Harbour Commissioner's meeting. The main problem was space for ships to come through. In one such case, a ship got stuck between the two secure parts of the bridge and held up traffic for days until it was finally freed. The suggested new bridge was to be a swivel one. On 2 August 1875 Anglesea Bridge was given the go-ahead by law to be removed. It took three years to raise funds for the removal and the rebuilding of the structure. London Engineer T. Claxton Fiddler was appointed engineer of the new bridge in March 1879.

As the years went on, the time came again for the replacement of Parnell Bridge. It was first looked for by the Corporation in 1946 but it was twenty years before Parnell Bridge could be rebuilt. On 10 January 1968 the real problems arose. Mr Sean McCarthy, the city engineer at the time, found a crack in the road surface at the southern end of the bridge. Parnell Bridge was closed as the effects of one crack were dangerous to the population crossing the bridge.

By 1969 a temporary bailey bridge was placed across the South Channel at Morrison's Island. The old Parnell Bridge was finished, and it was demolished by November 1969 and a new structure was built. Built of cement and stone, the new Parnell Bridge was opened on 24 May 1971 by Lord Mayor Peter Barry TD. The lamp standards that were on the 'Swing Bridge' are now historical monuments in the city and are located at the eastern end of the South Mall near the bridge.

Postcard of Anglesea Bridge, South Mall, *c.* 1900.

Parnell Bridge from the penthouse of the Clayton Hotel, present day.

## A Country on Display: Cork National Exhibition

One of the greatest events held in mid-nineteenth-century Cork was the Cork National Exhibition in 1852. The inspiration for the event itself came from the 1851 London Exhibition in Crystal Palace. An eminent Cork merchant, Daniel Corbett, and the editor and proprietor of the *Cork Examiner*, John Francis Maguire, visited the London Exhibition in 1851 and both returned home pressing for a similar exhibition to be held in Cork. According to Maguire, it was to be a public display of the country's capabilities and resources. National steam and railway companies facilitated the transport requirements of the committee by providing free transmission of all articles intended for the exhibition. A sum of £100 was also donated by Prince Albert to this Irish undertaking.

The Corn Exchange was chosen as the site of the exhibition. The building itself possessed a handsome front of stone, fronted onto Albert Quay, and had a small dome in the centre of its roof. On previous occasions, the hall had been frequently used for concerts. A new and large gallery or transept was constructed, which ran at the southern extremity of the Corn Exchange Hall that was parallel to the quay. In the Southern Hall or the Fine Arts Court, works of national sculptors and painters were displayed. Jewellery and silver work and more costly descriptions of furniture were also exhibited here. A new machinery compartment was constructed at the eastern end. In addition, as the number of proposed exhibits grew, a new gallery was constructed at the eastern end. The Corn Exchange's ballroom was separate and detached until a new passage was built from the eastern end of the whole complex. Indeed, during the exhibition, the ballroom was used on several occasions for balls and for the delivery of lectures.

The Northern Hall was devoted to textile fabrics, which included poplins, tabinets, laces, ginghams, crochet, netting and other articles of a similar description. The great warehouses of these goods, from Dublin, Belfast and Cork, were all represented. Works described as 'Fancy' from the different industrial and charitable public institutions were also exhibited here. In addition, different kinds apparel were worn, and coats, hats, gloves were also on display. The western transept displayed furniture and upholstery of every kind and rougher descriptions of textile fabrics, friezes, tweeds and cloths were also represented. In the eastern transept, a miscellaneous variety of articles were on display. They were small and light in nature. In truth, nearly every shopkeeper's craft was represented here. These included glass, stoneware, cutlery, optical and surgical instruments, ornaments of all kinds, bookbinding, musical instruments, confectionary, plus other small specimens. Machinery of the larger and heavier kinds, agricultural implements, bells and every kind of metalwork were located in the compartment of the eastern transept. In the western compartment here, carriages, saddlery, leather, carpeting and products of Poor Law Union workhouse were exhibited.

After the exhibition ended, the exhibition hall was offered to the Royal Cork Institution. The structure was taken down and resurrected adjacent to their own building, the former custom house on what was then Nelson Place, now part of the Crawford Art Gallery on Emmet Place. The new hall was opened by the lord lieutenant on Wednesday 23 May 1855, was proclaimed the Athenaeum and was to be used for promoting the fine arts and practical sciences. Another national exhibition was held on the Cork Market site in 1883.

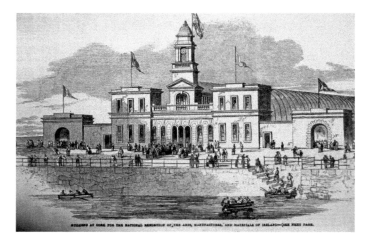

Cork National Exhibition Building, 1852, as depicted in the *Illustrated London News.*

Fine Arts Hall of the Cork Exhibition, 1852, as depicted in the *Illustrated London News.*

## The Carnegie Library Investment

Of all the philanthropists who have had an impact on the Western world, the most imaginative and probably the most profound donation/gift has likely been Andrew Carnegie's investment in public libraries – 660 across Britain and Ireland alone at the turn of the twentieth century. The foundation stone of the Cork Carnegie Library was laid by Andrew Carnegie in 1903 with the building opening in 1905. It was to replace a public library (established 1892) within the School of Art on Nelson Place. The new Carnegie Library was located on Anglesea Street next to Cork City Hall and had a lifespan of only fifteen years, closing in 1920.

A description in the *Cork Examiner* in 1905 reports that the style was Elizabethan with an elegant front, and a beautiful entrance, balcony and tower as added attractive features. At the main entrance from Anglesea Street was a vestibule, which opened into a large open hall, the floor of which was laid as a terrazzo executed by Italian workmen. Beyond

all this and in line with the entrance was 'the lending department, furnished in the most up-to-date manner'. The central portion of the building was lit mainly from the roof light. To the left of the lending library was the newsroom. Lined along the sides with neatly designed newspaper stands, the floor space was occupied by tables for the renders. The corresponding area to the left of the lending department was devoted to the reference library. A space in the southern side was partitioned off into a storeroom or workplace for the library attendant. Flanking the entrance on the ground floor were the librarian's offices on the left, and the ladies' reading room on the right, and over these respectively were the librarian's apartments and the juvenile reading room.

The library was lit by gas and specially designed pendants and brackets were fitted up in the reading rooms for the comfort of patrons. The heating and ventilation was on the plenum system, the heating chamber being at the northern side of the library adjacent to the Municipal Buildings. The heated air was controlled by means of a fan driven by an electric motor, and was taken by underground ducts to the various rooms, constructed on the best principles. Practically the entire sum of £11,000, which the generous donor provided for the establishment of the library, was absorbed into the work.

On 12 December 1920 the Carnegie Free Library on Anglesea Street in Cork was destroyed by a fire – lit by Black and Tans (members of the British Crown Forces) – as well the adjoining City Hall, and large sections of the city centre, especially St Patrick's Street. The burning of the library left the city without a public library service until 1924, when premises were provided on a temporary basis for a library in Tuckey Street. That service was transferred in 1930 to new premises behind a new Hiberno-Romanesque facade at Nos 57–58 Grand Parade.

Postcard of Carnegie Library adjacent to Cork City Hall, *c.* 1900.

## A Model School

The Cork Model School was designed by Enoch Trevor Owen, who was assisted by R. A. Gibbons on behalf of the Commissioners of National Education, and is an excellent example of Victorian architecture within the city. The Commissioners of National Education had requested that a model school be constructed for the Cork district due to the rapid increase that was taking place in the city's number of educational institutions.

Model schools were teacher-training schools under the auspices of the Commissioners of the Board of National Education, the administrative body of the national system, which was established in 1831. A central model school in Dublin was established in 1833/34. From 1845 onwards, twenty-five district model schools were established, including Cork Model School. Each year a number of male and female 'pupil teachers' were trained and housed at the school.

The model schools were managed by the local district inspector and their teachers were directly appointed by the Board of National Education. The Royal Commission on Education (1868–70) deemed that the model schools were an overly expensive method of teacher training and their use for this purpose ceased from around 1883 onwards, the model schools thereafter continuing to function as ordinary national schools. Following national independence in 1922, the National Education Board functions were taken over by the Department of Education.

The model schools admitted children of all denominations and social classes. However, in 1863 Catholic Church leaders banned Catholic pupils from attending because of dissatisfaction with the religious instruction provided. Thus, many model schools became Protestant in ethos, while in later years a number of others, including Cork, became Irish language schools (*scoileanna lán Ghaelige/Gael scoileanna*), teaching predominantly Catholic pupils. Notably, the registers and roll books record the attendance of a small number of pupils of the Jewish faith whose families arrived in Cork mainly in the 1890–1910 period. Past pupils at the school include former Lord Mayors Gerald Goldberg and Peter Barry.

MODEL SCHOOLS IN ANGLESEA-STREET, CORK.

Model School, Cork, 11 November 1865, as depicted in the *Illustrated London News*.

Cork District Court, formerly Cork Model School, from its backyard, now the site of its extension, August 2015.

Construction of the Cork Model School began in January 1864 and the school opened its doors for the first time on 11 September 1865. Among the attending students that day were forty-five infants (aged three to seven), sixty-one boys and a similar number of girls. Records show that its highest number of pupils reached over 450. Many of its original roll books are held in the Cork Archives Institute. These records show that pupils of varying social classes and denominations were among the students.

During its life, the model school served other purposes and records show that it once facilitated a maritime school, which included four small classrooms. It is also understood that the 18-metre-tall tower within the school was used as an observatory, and the maritime quarters of the school may have served an important role during the First World War. The school closed its doors in 1990. In 1994, the building was converted to a district court and remains in use in this capacity.

## The Greenwich Gun

The matter of time was an issue for the citizens of Cork in early summer 1916. Starting on 30 April, Germany and its First World War ally Austria-Hungary were the first to use a Daylight Saving Scheme as a way to conserve coal during wartime. Britain, most of its allies, and many European neutrals soon followed suit to provide more time for

agricultural activities in the evenings. Russia and a few other countries waited until the subsequent year and the United States of America implemented it in 1918.

Irish society operated on twenty-five minutes and twenty-two seconds behind Greenwich Mean Time. On 20 May 1916 Cork citizens woke up to find the new British Daylight Saving Scheme in full operation. All official clocks, at post offices and elsewhere, were duly put forward as required by the new act. All other clocks showing time to the public on the streets of Cork were similarly advanced during the night.

As the summer passed, the end of September 1916 meant that Great Britain had to revert to the normal time. Ireland decided, however, not to revert to the 'old time', but to try another change – that of adopting Greenwich Mean Time. The legislation to change this was argued for principally by the Irish port authorities and Chambers of Commerce and Shipping. It meant that for the immediate future at all events there would be no difference between English time and Irish time. Ireland made up the twenty-five minutes in time by simply putting back her public clocks, and her citizens their watches, not by sixty minutes but by thirty-five minutes on the night of 30 September 1916.

One prominent feature of the city's interaction with time and of British imperialism was effected – the time gun on Cork's Marina (one of many operating in British port cities). Established in 1876, as recorded in the minutes of the meetings of the Cork Harbour Commissioners, the gun – an 18 pounder – stood on a platform built for it at the city end of the Marina. The platform surmounted a small building within which a tide register was fixed. Precisely at 10 a.m. every morning, the exact solar time was transmitted by telegraph from the Royal Observatory at Greenwich direct to the Harbour Commissioners' Office on Lapp's Quay, where its reception was availed of to correct a chronometer of beautiful construction. The dial of the clock showed three indices, one indicating the hours, another the minutes, and the third the seconds; each index has two hands – one showing Greenwich time and the other Cork time, the difference being twenty-five minutes, twenty-two seconds. The daily transmission of Greenwich Time by wire to the indicator set beside this clock ensured the clock itself was always kept strictly according to true solar time. The accuracy of the clock influenced the firing of the signal gun.

At the very instant that the dial showed 1 p.m., Greenwich Time of 12 hours, 34 minutes, 38 seconds, Cork time, the movement of the second hand released a hammer, which falling, sent a strong electric current through a wire that connected it with the fuse in the breech of the signal gun. It discharged instantly, informing the public of the correct time. The gun was in the care of a man specially charged with it by the Harbour Board, and it was his duty, twenty minutes or half an hour before the time for the explosion, to charge the gun with a 3 lb cartridge, fix the fuse and attach the electric wire to it. A similar provision was made for signalling the correct time to the public on land and water at Queenstown (now Cobh). The Greenwich Time was received at the Harbour Office on the waterfront, and by like arrangement to that in Cork, a gun was to be fired near the lifeboat house, at the eastern end of the town. To mariners, this was a great opportunity to correct their chronometers before departing the harbour.

By the early 1920s, post Anglo-Irish Treaty, the Marina gun became an expression of a kind of throwaway imperial object as it lay defunct, and for many years of the early to mid-twentieth century lay on the grass. It finally disappeared physically and from memory.

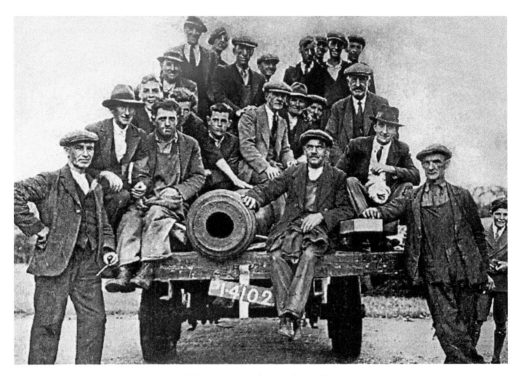

Supposed picture of the removal of the Greenwich gun from the Marina, 1930s.

## Connecting the City: Bus Station

Bus services have been an integral part of Cork city for over ninety years. In Cork, bus passengers said farewell, from Monday 16 October 1944, to the depot at Nos 40–41 Grand Parade, which the Irish Omnibus Co. had opened as the terminus for country buses in Cork in 1927. Services moved on that day to the building at the junction of Parnell Place and Anderson's Quay, which was itself replaced in 1960 by the foundations of the present bus station.

Few among passengers or staff mourned the passing of the old Grand Parade depot, which even by 1939 had become too small and congested for the growing numbers of people travelling by bus. An internal Great Southern Railways report in July 1939 had described 'scenes of congestion and chaos which would not be allowed in any civilised city' at the Grand Parade depot during peak travel periods.

From January 1945, the GSR became part of Córas Iompair Éireann – the new national transport organisation formed by an amalgamation of the GSR with the Dublin United Transport Co. The familiar red-and-white colour scheme of the Cork buses gradually gave way to the dark green livery of the new company. This nostalgic loss was balanced somewhat by growth and expansion, the end of the war in Europe bringing restoration of services, the opening of new routes and the advent of new buses to replace those worn out by the abnormal operating conditions of the emergency period.

A glance through the timetable booklets of the Cork City Services from 1946 onwards shows a pattern of continuing expansion of the routes and improvements in the frequencies of services to meet the needs of a growing city. Throughout those years, housing development continued apace in all parts of the suburbs, both by Cork Corporation and private building firms. Many of the traditional Cork industries expanded their workforces to cope with the growing demand for their goods and their need to draw workers from wider catchment areas created a bigger demand for bus services throughout the city.

A major reorganisation of bus services in the city came into effect in June 1955. The pattern of routes established at that time was a complete departure from the traditional route layout, which had been extended on an ad hoc basis since the early 1930s. It formed the basis of the city bus network for many years to come. Some of the principal cross-city routes in today's network have their origins in the foresight and forward planning that was a feature of the 1955 scheme. Further changes in the city bus network were made over the following years to meet changes in the pattern of travel demand, which unfortunately did not always mean expansion of business.

Cork Bus Station, summer 1946.

Parnell Place Bus Station, present day.

# 4. Along the River

## Lifting the Pages of History: Brian Boru & Clontarf Bridges

In 1905 the city's primary railway company was given royal permission to construct railway sidings on the quays. The idea of building such structures was the brainchild of Cork Corporation since the middle of the previous century. Before this, the Custom House and quay were bought in 1903 from the Board of Works. It was upstream from here that the sidings were to be constructed. Unfortunately, two major problems existed at the time. The first problem arose in regard to the link between the sidings. The two points to be linked were the National Network at the Great Terminus and Western Terminus and the West Cork Railway Terminus and Albert Quay.

Secondly, if a crossing was built, what would happen to the shipping industry in Cork? At this time it was essential for cargo ships to operate right up as far as St Patrick's Bridge on the North Channel and beyond Parnell Bridge on the South Channel. Hence, the bridges built would have to let shipping through. Many types of bridge were discussed, especially the centre arch moving bridge. Eventually, a design was chosen. After many discussions, the proposed bridge was to have a 'Scherzer Rolling Lift Bascule Bridge', consisting of four sections resting on steel piles with a concrete overlay. Practically, the mechanisms would not take up any quay space and they were deemed to have a relatively fast opening element.

Brian Boru Bridge on the North Channel was to be approximately 66 metres long and Clontarf Bridge on the South Channel was to be approximately 56 metres in length – each would have an opening span of approximately 18 metres. They were to be painted red because red is a bright colour, and therefore ships would be able see them clearly. Small engine rooms were built on elevated platforms to control the operations of the bridges and the equipment installed was both electric and manually operated. The two bridges were built in an upright position and it was only upon completion that they were lowered to the horizontal. Both bridges were opened on 1 January 1912.

By the early 1950s, both these bridges had ceased opening to let shipping through and this was only forty-two years after their initial opening. In 1954 Brian Boru Bridge was revamped. Three years later, in 1957, Clontarf Bridge underwent the same treatment. As well as being reconstructed, the two bridges became the dull colour grey instead of the bright colour red. As a result, disaster struck at 2.50 p.m. on 3 November 1965 when a 1,200-ton cargo ship, *The City of Cork*, ploughed into Clontarf Bridge to a distance of 2 metres. According to the *Cork Examiner* the following day, 'the City of Cork came upstream shortly before 3 p.m. intending to berth at Albert Quay, near the City Hall ... At 2.50, the vessel approached the bridge but did not stop, despite the fact that the anchor was dropped in an effort to halt it. It continued on and struck the steel and timber bridge and the bow ploughed about eight feet into the structure.'

76

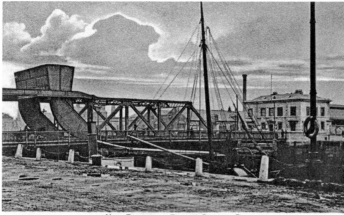

NEW BRIDGE AND BANDON STATION, CORK.

Clontarf Bridge, *c.* 1910.

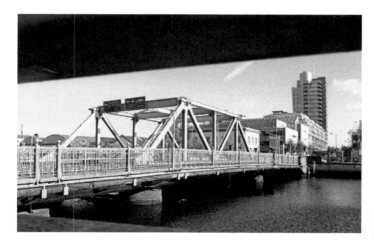

Clontarf Bridge,
present day.

Fortunately, nobody was hurt as all the people on the bridge had seen the ship coming and abandoned their cars in order to run to safety. From this disaster it was found that the main supporting girder was fractured and needed replacing before the bridge could be reopened. It took a week to fix and the girder had to be transported, all 12 tons in weight, from a disused railway bridge in West Cork. On 9 November 1965 the bridge was tested with the full weight of a steam train crossing it and soon was fully operational again. Brian Boru and Clontarf Bridges were revamped yet again in the late 1970s and this result can now be seen today. Both bridges still retain their original ornate look but unfortunately today do not operate as lifting bridges anymore.

## Meet Me at the Statue

For over 150 years the Father Mathew statue has stood at the eastern end of St Patrick's Street. Enshrined in Cork city's collective memory as the 'Apostle of Temperance', by the end of 1840 it is recorded that 180,000–200,000 nationwide had taken Father Mathew's

pledge. In the late 1840s, Father Mathew went to North America to rally support for his teetotaller cause, and the teetotalism cause in Ireland and England started to suffer by his absence. He died in December 1856 and was buried in St Joseph's Cemetery, Cork, his own cemetery that he created for the poor. Father Mathew has left a legacy in this city that has been maintained and respected since his death. Of all his commemorative features in the city, the Father Mathew Statue, erected in 1864 on the city's St. Patrick's Street, very much honours the man.

Soon after the death of Father Mathew in December 1856, a committee was formed for the purpose of erecting a suitable memorial in the city. The commission was entrusted to the famous sculptor John Hogan who in his early days had been raised in Cove Street and was acquainted with Father Mathew. Hogan died in 1858 and on his death a meeting of the committee was called. The commission was handed over to John Henry Foley. At forty years of age, the sculptor had achieved the highest honours. Foley's output was prodigious and his works are to be found in India, USA, Ceylon, Ireland and Scotland. His subjects were deemed classical and imaginative, creating equestrian statues, monuments and portrait busts. Two years after the unveiling of the Father Mathew statue, his Daniel O'Connell monument in Dublin was unveiled.

The Father Mathew statue was unveiled on 10 October 1864 amid a concourse of people and public celebration. The following day, both the *Cork Constitution* and *Cork Examiner* carried lengthy and vivid accounts of the pomp and ceremony. The statue had been cast in the bronze foundry of Mr Prince, Union Street, Southwark, London. As well as obtaining

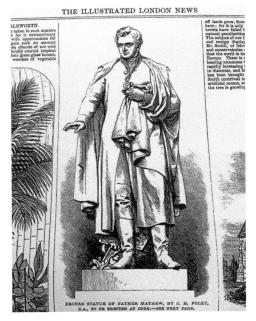 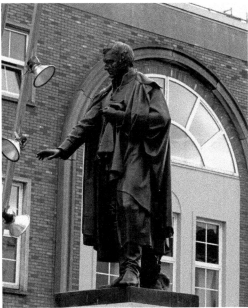

*Left*: Father Mathew statue, as depicted in the *Illustrated London News*, 26 December 1863.

*Right*: Father Mathew statue, present day.

a remarkable likeness of Father Mathew, the sculptor posed the figure as a representation of him in the act of blessing those who had just taken the pledge. On the statue's arrival in Cork, it was placed on the stone pedestal that had been designed by a local architect William Atkins.

The proceedings on 10 October began at noon when it was estimated that thousands of people lined all the vantage points on the city's streets. All businesses had been suspended for the day and public buildings and private houses were decorated for the occasion. The city remained thronged with people from 10 a.m. to 4 p.m. A huge procession had assembled on Albert Quay and the Park Road and moved off at 12 noon, headed by the Globe Lane Temperance Society of fifty members and twelve performers in their band. All the trades, societies with their banners, sashes and coloured rosettes marched with Temperance Societies from all over the county. At 2 p.m. the statue was unveiled to a mass of public support. Henceforth it was immortalised as a landmark, defining the centre of the city and supporting the story and folklore of Father Mathew on the great St Patrick's Street.

## A Place for every Creature: Murphy's Dog Trough

Beneath the pavement outside No. 121 St Patrick's Street, tucked in against the front wall is a little drinking trough for dogs. The trough is of Cork limestone and is just over 60 cms in length, with the word *Madraí* (Irish for dogs) carved in an elegant Gaelic script on its front. The drinking trough was commissioned around 1960 from the Cork sculptor Seamus Murphy by Mr Kenny Stokes when the premises was the Milk Bar, one of Cork's most favoured tearooms of the 1950s.

Born near Burnfort, County Cork, in 1907, Seamus Murphy was one of the foremost stone carvers and sculptors of his time. From 1922 until 1930 he worked as an apprentice stone carver at O'Connell's Art Marble Works in Blackpool, Cork. He received a scholarship in 1931, which enabled him to go to Paris where he was a student at Academic Colarossi

Dog trough, sculpted by Seamus Murphy (present day).

and studied with the Irish-American sculptor Andrew O'Connor. After returning to Ireland, Seamus worked in O'Connell's stone yard. In 1934 he opened his own studio at Blackpool. Among his first commissions were the Dripsey Ambush Memorial and the Clonmult Memorial at Midleton, two statues for Bantry Church and a carved figure of St Gobnait in Ballyvourney graveyard.

*The Virgin of the Twilight* was exhibited at the Royal Hibernian Academy in 1944, and was later erected at Fitzgerald's Park, Cork. In 1939 he exhibited at the World Fair, New York. In 1944 he was elected associate of RHA (Royal Hibernian Academy). That same year he married Maighréad Higgins, daughter of Cork sculptor Joseph Higgins. In 1945, Seamus designed Blackpool Church for William Dwyer and in 1948 he carved the Apostles and St Brigid for a church in San Francisco. Another of his sculptures is in St Paul's, Minnesota. He was made a full member of the RHA in 1954. He became professor of sculpture at the RHA in 1964, and was awarded an Honorary LLD by the National University of Ireland in 1969.

## Matters of Compensation: St Patrick's Street

Check out the early twentieth-century architecture on the Father Mathew statue end of St Patrick's Street. Arson attacks during the Burning of Cork in 1920 by British Auxiliaries, named the Black and Tans at the time of the Irish War of Independence, led to large portions of the city's main street buildings, city hall and library being destroyed. A committee had been set up in the Cork Corporation to engage and collect data and for the Westminster government, which was to be used in the compensation negotiations with the English government regarding the damage done to St Patrick's Street and the wear and tear of British trucks across the city's streets.

A total of £300,000 had been advanced for the reconstruction of St Patrick's Street. The Cork Corporation's City Solicitor noted that two investigators appointed by the Irish government and one by the British government had visited the city in the second week of August 1922. The British government representative was dealing with cases of damage done by their forces, which was the bulk of the damage in Cork city. He made a promise of a cash payment to the decree holder, i.e. Cork Corporation.

Coupled with this mechanism and it appears to muddle the compensation package available, an international body called the Compensation Commission (the Shaw Commission) had been set up, which was appointed for the express purpose of, among other things, reviewing awards already made in the cases of criminal injury applications not defended by a city or county council. Cork Corporation in mid-September 1922 was expecting the Shaw Commission to come to Cork. The minutes of the Corporation of Cork show the council attempting to understand the two sources of compensation packages and the need to maximise any receipts of compensation packages.

Cork Corporation council members pressed to harness the advance of £300,000 to provide the much-needed employment. An important decision was also taken to inform property owners within the destroyed area that the Corporation intended to enforce the bylaws with regard to the closure of temporary structures or timber-walled shops. In the early part of 1921 they had emerged on the street and through good will from the Corporation had been allowed to stay but no legal right existed for their

Debenhams (formerly Roches store) and Brown Thomas (formerly Cashes); both buildings were opened in 1927.

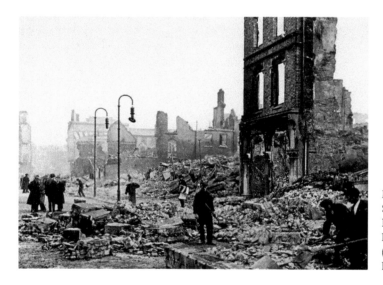

Middle of St Patrick's Street following the Burning of Cork, December 1920 (now the site of Penney's Drapery Store).

erection. A subcommittee of the Corporation was to wait on the owners of property in the burnt-out areas who had submitted plans for reconstruction work. The Corporation urged them to proceed with the work. Subsequent to the Corporation's plea, at a meeting, the councillors were informed that six firms in the burnt-out area were prepared to start rebuilding work. In several cases, traders informed the Corporation that tenders had been invited and in some cases, works had already started. The reality was that a large number of traders were not prepared to start. They were holding out to maximise any due compensation. Indeed, it was to take until 1927 for the elegant old Roches Stores building (now Debenhams) and the old Cashes Building (now Brown Thomas) to be reconstructed.

## Beneath the City: a Street Culvert

At low tide on St Patrick's Bridge, look into the river on the eastern side where the bridge meets Merchant's Quay. Here is one of the city's culverts. On eighteenth-century maps of Cork city, a myriad of quays and canals are shown across it. Cork's central canal lined the centre of the newly reclaimed area, admirable buildings on both sides bearing a special relationship with the water. By 1790 many of these were to be filled creating wide and spacious streets like St Patrick's Street, Grand Parade and the South Mall.

Very little is known on the nature of city's culverts, many of which in the past straddled river channels of the Lee. Every now and again, utility and Corporation workers dig up our streets and encounter the culverts and ultimately many have to be replaced to accommodate the modern city. On 14 October 1924 Mr Ryan, the council's building inspector, submitted an insightful report to the city councillors on the condition of the underground arch under St Patrick Street. He drew the Corporation's Public Works Committee to a number of defects. There was a noticeable increase in the tendency of the arch stone to slip. The side walls forming the abutments of the arch were in a wretched condition; in parts they resembled more a heap of stones loosely tipped from a cart than a wall systematically built. A considerable amount of silt helped to save those side walls from the scouring action of floods, and by its weight to retain them in position. The loose open joints of these walls admitted the free tunnelling of rats to adjoining premises. The continual working of the tide through these walls removed a certain amount of subsoil, and this the architect proposed would eventually lead to a subsidence of the adjoining ground with the drainage connections.

The unbraced concrete foundation of the pavement and the wood blocks above, both of which were atop the foundation over the arch, saved it to a great extent. As the high tide level was much higher than the crown of the arch, the tide removed supporting soil. An amount of timbering or bracing had been fixed in the archway. The archway was the main sewer of the city, and received the sewage from all the sewers in the side streets; its bed was the old riverbed and even if in good condition, it was self-cleansing. The city's tramlines were directly over it in places, and an amount of inconvenience would be experienced by the failure of any part of the arch.

On the subject of a culvert on Sheare Street, the inspector noted several defects:

The crown of the arch is close to the surface of the road ... The arch is affected by the impact of heavy laden lorry wheels. The arch varies in sectional area, and the change from one section to another is made by direct offsets, which slow down the flow and exposes the masonry to the scouring action of the floods. Where the sectional area of the arch is wide, as in spanning 16 to 20 feet, two lorries can travel abreast, transmitting practically all their weight to the arch.

The inspector proposed that the arch be replaced with a new one of smaller span; that arch would be stronger and the weight transmitted to it less, and it could also be possible to obtain a greater depth between the road surface and crown of arch, which would facilitate the laying of gas, water of electric conduits, where they had to cross the arch. The inspector concluded with options for replacing the archway with a pre-cast concrete pipe, a small brick sewer or concrete culvert.

Culvert at St Patrick's Bridge, present day.

## The Sweep of History, St Patrick's Bridge

In the mid-eighteenth century, industry in Cork was rapidly growing. The manufacture of cloth, wool and cotton were important to the city's commerce. The Port of Cork was used as a place for meeting other ships of the same nature. These ships came from and went to places like the West Indies and the east coast of the United States up until the American War of Independence. However, it was the butter trade that made Cork a wealthy city. Butter was exported to every part of the known world from the butter market. Since many of the industries in Cork in those days were based on the north side of the city, a new bridge was proposed by the expanding population.

Opposition also reigned in the city, especially the businessmen near the proposed site and the ferryboats that operated the River Lee. Their petition to Cork Corporation was turned down and in 1786 the go-ahead for the raising of money for the project was given. It was decided by the council of the city that loans would have to be taken out and would have to be paid back with interest. However, the loan or the £1,000 contribution from the council was not enough to pay back the financial institution, plus interest, that loaned the money. Tolls were placed on the proposed bridge and the aim was to abolish them twenty-one years later. Michael Shanahan was chosen to be the architect and chief contractor of the operation. On 25 July 1788 of that year, the foundation stone was laid.

Unfortunately, on 17 January 1789, during construction disaster occurred as a flood swept through the Lee Valley. A boat tied up at Carroll's Quay (then Sands Quay) broke loose and crashed against the uncompleted centre arch (i.e. the keystone) and destroyed

it. Michael Shanahan was devastated and set off to London to find new prospects. He returned though to rebuild the bridge, which was christened on 29 September 1789.

Fast forward to November 1853, disaster happened again when St Patrick's Bridge was swept away by flood. This was due to a build-up of pressure at North Gate Bridge, which was the only structure to remain standing while the flood swept over the city centre, claiming several lives and destroying everything in its path. John Benson was to be the architect and he chose Joshua Hargrave, the grandson of the Hargrave that worked on the first bridge, and other contractors to build the structure. Hargrave was chosen mainly because of his reputation and the price of building the bridge. In November 1859 the new St Patrick's Bridge was opened and christened. Disaster struck again when the bridge had to be reconstructed due to a ship that struck it. It was built again and was opened on 12 December 1861 for public traffic. From here on the bridge's luck has remained intact and still elegantly spans over the rushing waters of the River Lee.

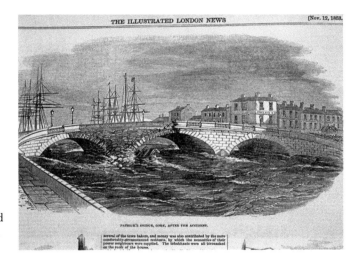

St Patrick's Bridge, 1853, damaged by a flood as depicted in the *Illustrated London News*, 12 November 1853.

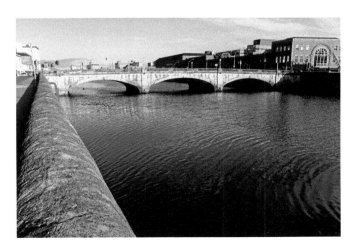

St Patrick's Bridge from Camden Quay, present day.

## A Work of Genius: St Mary's Church

The Dominicans came to Cork in 1229 on the invitation of the Anglo-Normans and initially settled themselves on an inlet in the south channel of the River Lee where the Crosses Green apartments now stand. This site was excavated in 1993 and the remains of their medieval abbey were uncovered. In 1697, the Dominicans were forced to leave this inlet due to the fact that their lands and buildings were confiscated by Henry VIII of England. The Dominicans consequently moved to a laneway off Shandon Street and established their own small religious buildings. It was here in the 1800s that a Dominican named Father Bartholomew Thomas Russell first came up with the idea of building Saint Mary's Church on Popes Quay. His idea was adopted by the local bishop and funds were granted. In November 1832 the foundation stone was laid.

One of Corks greatest architects (in the 1800s) Kearns Deane was chosen to design the church. Some of his other works include the admired Cork Savings Bank on Lapps Quay and the courthouse on Washington Street. Deane's design is neoclassical and mirrors on a Greek style of architecture, a portico or entrance with several pillars in a row supporting a peaked ornate-style canopy. The masonry of the church was the work of stone merchants named Thomas & James Fitzgerald on the Grand Parade. On Sunday 20 October 1839 the church was blessed for public worship by the bishop of Cork, the Most Revd John Murphy DD. The preacher was the archbishop of Armagh and primate of all Ireland, the Most Rev William Crolly DD, while the most famous of the dignitaries present in the crowd on the opening day was Daniel O'Connell, 'the Liberator', a famous statesman in Irish history.

St. Mary's Dominican Church.

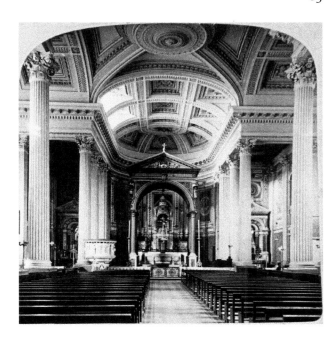

Interior of St Mary's Dominican
Church, *c.* 1910.

In 1861 architectural additions were added to the church in the form of a portico or covered walk area. The contractor was P. J. Scannell, who later worked on enlarging the sanctuary. The columns that hold up the portico are approximately 10 metres in height and are positioned on top of ten steps. The statue of our Lady, which is situated at the top of the portico, was put into place in 1861 and is the work of Mr James Cahill of Dublin.

In 1897 the organ was built by Messrs Conacher & Co. of Dublin and placed in a constructed organ gallery. Seating kneelers and dividing rails were also put into place in the church while the portico was being constructed. The initial stations were supplied in 1872 and consisted of oil paintings in large wooden frames. These were replaced in 1969 by the present stations, which are the work of a wood-carving industry in the Dolomite Alps of northern Italy. They are hand carved. Other features that were added in the late nineteenth century include the altars, the sanctuary, the tabernacle and a baldacchino, made up of four columns of Granite holding up a pediment (the main altar). The pulpit in St Mary's is made of marble and shows five Dominican saints: St Dominic himself, St Thomas Aquinas, St Catherine of Siena, Pope Saint Pius V and Vincent Ferrer. The ceiling is supported by columns of Corinthian architecture. These columns are the crowning glory of St Mary's Dominican Church.

## A Palace of Varieties

The Everyman was designed by Mr Henry Brunton and built in around 1840 by Mr John O'Connell. Located on the street front of MacCurtain Street, this terraced two-bay, three-storey building was originally built as a house, which was part of a group with the adjoining houses to the east and west.

In 1897, Dan Lowry opened the building as a luxurious new theatre called the Cork Palace of Varieties. Its origins as a beautiful Victorian theatre is reflected in the interior

of the building with its impressive ornate proscenium arch and boxes and a balcony and ceiling composed of decorative plasterwork, which has been restored to its former glory.

During the heyday of music hall theatre, 1897–1912, no expense was spared in securing the best talent available at the time. Artists such as Charlie Chaplin, George Formby and Laurel and Hardy, to name a few, performed there during this time.

With the arrival of the 'talkies', the Palace became a cinema in 1930 and remained so until 1988. The venue reopened as a theatre in 1990 when it was purchased by the Everyman Theatre Co. The names of the venue and the theatre company were combined to form the Everyman Palace Theatre, but it is now known as the Everyman.

The Everyman is now one of the busiest presenting and producing theatres in Ireland, playing host to production companies as well as diverse acts such as Ed Harris, Tommy Tiernan, Rosaleen Linehan, Glen Hansard and Marketa Irlova. It incorporates a diverse and eclectic programme of world-class theatre, dance, music, visual arts, pantomime and variety shows.

The Everyman specializes in drama and receives regular visits from companies such as Druid, Blue Raincoat, The Abbey, Second Age and London Classic Theatre.

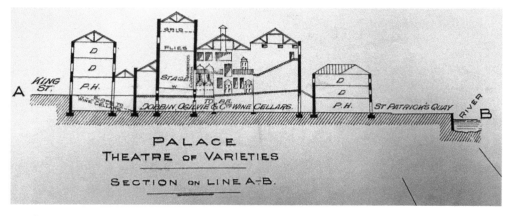

Goad's cross-sectional drawing of the Palace of Varieties, 1897.

Façade of the Everyman Palace, present day.

## Musgrave's Metropole Hotel

In 1876 the brothers Stuart and Thomas Musgrave opened a grocery on North Main Street in Cork. They were aged twenty-five and eighteen and had moved to Cork from County Leitrim. The business was incorporated in 1894 as Musgrave Brothers Ltd, with a charter to retail and wholesale sugar, coffee, tea, spices, fruit, olive oil and other foodstuffs. The company also ran a bakery and confectionary and was listed as a mineral water manufacturer, iron and hardware merchant, druggist, fish and ice merchant, stationer and haberdasher.

At the same time, the Musgrave Brothers built and ran Cork's iconic Metropole Hotel, as well as a sweet factory and a laundry. The prospectus for the hotel, in 1897, sold its luxuriousness and taste throughout the new building. It was to embrace the 'necessary public rooms, including spacious dining room, ladies' writing and drawing rooms, private sitting rooms, commercial room, billiard room, smoking room, and numerous stock rooms, together with fifty well-appointed bedrooms'. In addition, the prospectus highlighted the comforts needed for the visitor: 'The comfort and requirements of commercial gentleman will be a special feature, and a writing room for their exclusive use will be provided on the principal floor. Careful attention has also been given to the important matter of stock rooms, which will be numerous, conveniently situated, and wall lighted.'

A novel feature of the new hotel was its promenade roof gardens (introduced for the first time in connection with an Irish hotel), affording the unique attraction of a promenade extending over the flat roofs of entire buildings. The roof garden was to be reserved for exclusive use of hotel visitors, commanding an extensive view of the city and surrounding scenery. Connecting each floor and entrance hall was an electric passenger elevator.

The first Musgrave grocery relocated to larger premises at No. 84 Grand Parade and by 1896 the brothers had opened a grocery in Tralee, County Kerry. In 1925, the company

Metropole Hotel, *c.* 1910.

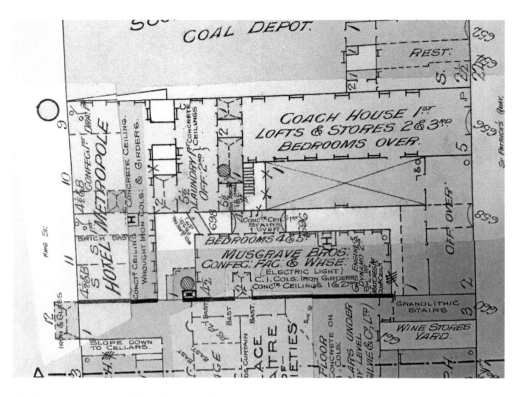

Goad's insurance plan of the Metropole Hotel, 1897.

moved to a large new premises on Cornmarket Street. The extensive grocery warehouse gave the company significant competitive advantage over other wholesale grocers in the area. By this time the business was almost exclusively wholesale. Musgrave now serves more than 3,000 stores in Ireland, the UK and Spain and has annual wholesale turnover of €4.4 billion and global retail sales of €6.7 billion.

## Cake Specialities, Thompson's Bakery

At the eastern end of MacCurtain Street lies the historical legacy of the headquarters of Thompson's Bakery. According to the stained-glass panel over one of the windows, F. H. Thompson & Son Ltd established the Bread and Cake Factory in 1826. It operated until 1984. The present twelve-bay five-storey building was erected around 1890 and was built from red brick with some sandstone.

The Thompson family has a long and proud history. The Thompsons ancestors were Huguenots on one side and English on the other. The French branch, the Malenoirs, were refugees who fled from France to the South of England after the Edict of Nantes. They eventually sailed from Bristol to Cork aboard the *Grafton* around 1761.

The family opened their first bakery by Clarkes Bridge in Cork city in 1826. From humble beginnings, the company's success was phenomenal and it developed and expanded into one of the country's best-known and most reputable bakeries with its products being sold

throughout Ireland, and a number of famous special tin- and carton-packed cakes being exported throughout the world.

The company had number of retail outlets, namely four shops in Cork city together with two cafés and a snack bar. From its headquarters in the huge bakery in Cork city's MacCurtain Street, in the 1970s Thompsons' output tops 20 million products per annum. The company employed 250 men and women. It distributed Thompsons' famous bread throughout Munster and the confectionery is sold throughout Ireland, with depots in Waterford, Dublin, Athlone, Galway, Westport and Limerick. Thompsons' vans were a very familiar sight throughout Munster's forty routes and ten national routes, and numbered in the region of sixty.

During this time F. H. Thompson & Son won many awards at international baking competitions in London and was twice voted Champion Bakers of All-Ireland. Thoma was the registered name for the firm's famous brown malt loaf, which has tickled the palate of customers for fifty years. Their plum puddings were a Christmas favourite with everyone and they contain a liberal measure of the 'hard stuff', so a Blue Label or a Father Christmas pudding is an absolute must on tables throughout the festive season.

Thompsons' Barn Bracks were traditionally one of the most popular products and were made with the finest yeast-raised dough, eggs, sultanas, lemon and orange peel. The company's special breads were as well known as their confectionery. The Vienna loaves and rolls, which required special baking techniques, were favourites with everyone who had tasted them, as were the traditional soda cakes, which are made from a flour specially selected from a local mill and are hand baked. Swiss rolls and sponge sandwiches were yet another specialty, while

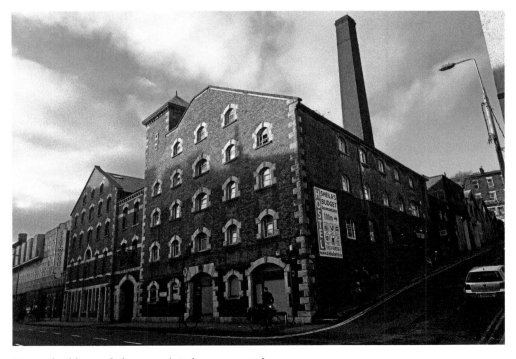

Former buildings of Thompson's Bakery, present day.

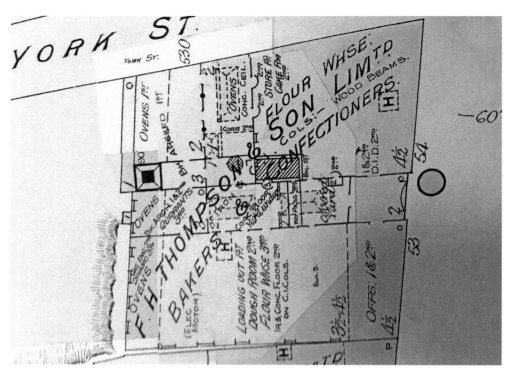

Goad's insurance plan of the interior of Thompson's Bakery, 1909.

their special cakes, which included wedding, birthday, celebration cakes as well as torten and continental gateaux, were of the finest quality.

Thompsons pioneered the export of top-quality bakery produce from this country. They introduced a tinned whiskey cake, which met with great success abroad. Due to demand, they exported three varieties of cake that are shipped all around the world — Blarney, Irish whiskey and Dundee cakes.

## A Spire of Time: Trinity Presbyterian Church

The first recorded Presbyterian congregation in Cork dates back to 1675. At this time, the majority of the members had English backgrounds and the records show that the first minister was a Revd Brinkley, who had fifteen followers in all. Evidence also exists stating that their first church was built before 1717 on Duncombe's Marsh, present-day Prince's Street area. This building in later years became known as the Prince's Street Church. This church still exists today.

Over 100 years later in 1831, it is recorded in the minute book of Trinity Presbyterian Church that a number of Cork Presbyterians of Scottish ancestry wished that a new church be built to hold their congregation and that would obey the doctrine and government of the Church of Scotland. In 1832 this congregation first met in a house in Tuckey Street. This set-up was to be short-lived as in 1841 a new church was built on Queen Street, present-day Father Mathew Street (adjacent to Holy Trinity Church). This building was known as the 'Scot's Church'.

Trinity Presbyterian Church, present day.

An increase in the population in the city in the mid-nineteenth century led to further interest in this religion by people, the result being that because of an increase in the congregation, a vote was taken that a new church would have to be built. On 28 July 1861 Trinity Presbyterian Church was opened at the foot of Summerhill. The architect was Englishman Mr Tarring, who was complimented at the time for his fine decision to combine the native limestone with his own native stone, Portland stone and Bath stone. Within the interior, one can see clearly the pulpit is central, which is supposed to emphasise the importance of God's word from the scriptures. The absence of pictures, statues and other decoration also adds to this effect. Apart from the pulpit, the stained-glass windows are the only other dominating features inside. These again dominate the exterior along with a very elaborate spire. Unfortunately, due to a bad foundation, this spire is distinctively crooked but adds a great level of grace to this corner of the city.

## Dark Journeys of Enterprise: the Railway Tunnel

The idea for the Great Southern & Western Railway (GS&WR) began in the 1840s and initially aimed to link Dublin to the southern provinces. The network was to cover 1,500 miles and the GS&WR were to become Ireland's largest railway company. In 1846 William Dargan, a highly successful contractor, was awarded the contract for the Thurles to Cork section of the line. Despite the difficult landscape conditions encountered, by 1849 the line had been constructed from Mallow to Cork. High embankments were needed along with three stone viaducts over the River Blackwater at Mallow, Monad and at Kilnap near Cork city. The railway's approach to the city quaysides was important. The initial route

proposed was along the Blackpool Valley (northern suburbs) and along the Kiln River. However, it was found that property acquisition was too expensive due to the built-up nature of the area. The second route proposed involved a route up the Glen River Valley, one of the rivers that flows into the River Kiln in Blackpool, in what is now the Ballyvolane area. However, the landscape there was found to be too steep. A third alternative was proposed and adopted, that of a tunnel to be bored through a sandstone ridge.

Under William Dargan and Sir John MacNeil, the boring of the tunnel began in the spring of 1848 and took seven years to complete. A temporary terminus was built at Kilbarry to accommodate the Dublin to Cork services. The tunnel had four ventilation shafts: two sunk on either side of what is now Assumption Road, one in Barrackton and the southernmost shaft at Bellevue Park. These can still be seen today in the Montenotte to St Luke's area, under which the tunnel runs. Work on boring within the tunnel was slow. The rock was so hard that it required large quantities of gunpowder to displace it. For its construction they used a novel kind of blasting agency by which the gunpowder was ignited by a kind of volcanic battery. On average, just over 1 metre per week was bored through day and night shifts.

Work was also hindered by fatal accidents. An accident of horrific nature occurred on Wednesday 23 August 1848 at the northern end of the railway tunnel. It was usual for the men who worked during the day to be relieved at 8 p.m. in the evening by another body who worked through the night. Upon this occasion the workmen ensued in sinking shaft No. 1, at Spring Lane, previous to departing the prepared several blasts to the number of 7, 6 of which exploded. After some time was permitted to elapse, they concluded that the seventh was extinguished, and the relief party accordingly proceeded to descend. The Cork examiner denoted that

> had two of the men alighted from the bucket, by means of which the descent was effected, when the blast exploded with unusual violence, directly under their feet. The men, whose names were Moynihan and Mahony, were dreadfully injured. Mahony's arm was nearly blown off, and was subsequently amputated at the North Infirmary, to which both sufferers were immediately conveyed. The other man's face was so mutilated that it was difficult to distinguish it as that of a human being, the features being completely destroyed. Neither of them were expected to survive. It happened singularly, that of three men, who remained in the bucket, no one sustained the least injury. The shaft not having been yet worked laterally, it was a mere perpendicular hole, and there was consequently no retreat except upwards.

On 29 August 1854, the headings of the tunnel of the Great Southern & Western Railway met. The viaducts between Mallow and Cork were put in place along with the bridges over the old Dublin Road and Spring Lane. In July 1856 the passenger building and train shed at Penrose Quay was erected. This was designed by architect Sir John Benson. Its centrepiece was a covered way, just over 60 metres wide, and was supported by twenty Doric columns. The problem of building the station on slob land was overcome by piling foundations. Six hundred beech piles, all just under 8 metres in length, were piled. The original Penrose Quay Station later became a cattle depot and its Doric colonnade was demolished sometime between 1895 and 1896. A small number of associated buildings have survived. These comprise the former station manager's house near Penrose Quay and the shell at the former goods shed, adjacent to the Cork tunnel entrance.

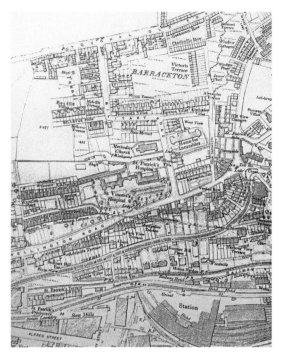

*Above left*: Tunnel line marked on a map of Kent Station and environs, 1900.

*Above right*: Kent Station and the tunnel, present day.

*Right*: Chimney funnel of Cork Blackpool Railway Tunnel, the Glen, present day.

## Quay Channels, the Steam Packet Office

Around 1824 St George Steam Packet Co. erected a premises known as the packet office on Penrose Quay, which they surmounted with a sculpted piece of St George slaying a dragon. The first two steamers employed by the St George Co. to and from Cork were the *Lee* and *Severn*, both built in Liverpool in 1825 (*Lee* for Liverpool trade originally and the *Severn* for Bristol trade).

As the reputation of the Cork site was being established, the St George Co. extended its operations with marvellous rapidity, until steamers were to be found in almost every port in the United Kingdom – in chief ports of Holland, Denmark and Russia as well. However, management of the St George Co. was not content with the situation and Mr Ebenezer Pike of Bessborough, Blackrock, County Cork, convened a meeting at the shareholders, which was held at Cork on 17 February 1843. Before the meeting, Mr Pike had forwarded to each shareholder a copy of a circular in which he proposed firstly to form a separate company from the English business with a capital of £50,000 in shares of £50 each, and secondly to build a new steamer of 500–600 tons burthen and 300 horsepower.

Former Cork Steam Packet Building, present day.

No definite decision was arrived at during the meeting itself. Nevertheless, in the following October 1843, the title St George was dropped and the title the City of Cork Steamship Co. was established. The name was later shortened to the Cork Steamship Co. Mr William Wilson, founder of the firm of Wilson, Son & Co, became the first general manager at Cork and a Mr McTear became the Liverpool agent. The first directors were Messrs Ebenezer Pike, John Gould, James Connell, Joseph Hays and William Lane, all merchants belonging to Cork.

Ebenezer Pike also did not abandon the idea for a new steamer. On 28 September 1843, Messrs Thomas Vernon & Son built the steamship *Nimrod*. In addition, the Cork company began to purchase other steamers. At this time the St George Steam Packet Co. owned around twenty steamers, and many were sold off to various buyers in favour of newer steamers. The new management of the new Cork company purchased seven of them.

Throughout its history the company suffered losses of vessels and lives at sea, including the loss of the *Sirius* in Ballycotton Bay in 1847. Losses in the First World War included the *Inniscarra*, the *Lismore* and the *Ardmore*. The sinking of the *Lismore II* in 1924 was later found by the Irish Free State's first investigation into a maritime disaster to have been caused by the movement of cattle. Losses in the Second World War included the *Ardmore II* in 1940, proven in 1998 to have been caused by a mine. Several new ships were built after the war, reusing former names such as Innisfallen and Glengariff. The latter's final voyage on 7 December 1963 marked the end of the Cork–Liverpool service.

In 1965, the Irish government took over the British and Irish Steam Packet Co. Ltd, together with its subsidiary City of Cork Steam Packet Co. Coast Lines Ltd were taken over by the P&O Line (formerly Peninsular and Oriental Steam Navigation Co.) in 1971.

Penrose Quay, *c.* 1910.

# About the Author

For over twenty years, Kieran has actively promoted Cork's heritage with its various communities and people. He has led and continues to lead successful heritage initiatives through his community talks, City and County school heritage programmes, walking tours, newspaper articles, books and his work through his heritage consultancy business. For the past eighteen years Kieran has written a local heritage column in the *Cork Independent* on the history, geography and its intersection of modern-day life in communities in Cork city and county. He holds a PhD in Cultural Geography from University College Cork and has interests in ideas of landscape, collective memory, narrative and identity structures.

Kieran is the author of nineteen local history books: *Pathways Through Time, Historical Walking Trails of Cork City* (2001), *Cork: A Pictorial Journey* (co-written, 2001), *Discover Cork* (2003), *A Dream Unfolding, Portrait of St Patrick's Hospital* (2004), *Voices of Cork: The Knitting Map Speaks* (2005), *In the Steps of St Finbarre: Voices and Memories of the Lee Valley* (2006), *Generations: Memories of the Lee Hydroelectric Scheme* (co-written, 2008), *Inheritance: Heritage and Memory in the Lee Valley, Co. Cork* (2010), *Royal Cork Institution: Pioneer of Education* (2010), *Munster Agricultural Society – The Story of the Cork Showgrounds* (2010), *Cork City Through Time* (co-written, 2012), *Journeys of Faith, Our Lady of Lourdes Church Ballinlough, Celebrating 75 Years* (2013), *West Cork Through Time* (co-written, 2013), *Cork Harbour Through Time* (co-written, 2014), *Little Book of Cork* (2015), *North Cork Through Time* (co-written, 2015), *Ring of Kerry The Postcard Collection* (2015), *Cork 1916: A Year Examined* (co-written, 2016) and *Cork City History Tour* (2016). In June 2009 and May 2014, Kieran was elected as a local government councillor (Independent) to Cork City Council. He is also a member of the European Committee of the Regions. More on Kieran's work can be seen at www.corkheritage.ie and www.kieranmccarthy.ie.